Location Audio

Location Audio Simplified

Capturing Your Audio . . . and Your Audience

Dean Miles

Taylor & Francis Group

NEW YORK AND LONDON

First published 2015
by Focal Press
70 Blanchard Road, Suite 402, Burlington, MA 01803

and by Focal Press
2 Park Square, Milton Park, Abingdon, Oxon OX14 4RN

Focal Press is an imprint of the Taylor & Francis Group, an informa business

© 2015 Taylor & Francis

The right of Dean Miles to be identified as author of this work has been asserted by him in accordance with sections 77 and 78 of the Copyright, Designs and Patents Act 1988.

All rights reserved. No part of this book may be reprinted or reproduced or utilized in any form or by any electronic, mechanical, or other means, now known or hereafter invented, including photocopying and recording, or in any information storage or retrieval system, without permission in writing from the publishers.

Notices
Knowledge and best practice in this field are constantly changing. As new research and experience broaden our understanding, changes in research methods, professional practices, or medical treatment may become necessary.

Practitioners and researchers must always rely on their own experience and knowledge in evaluating and using any information, methods, compounds, or experiments described herein. In using such information or methods they should be mindful of their own safety and the safety of others, including parties for whom they have a professional responsibility.

Product or corporate names may be trademarks or registered trademarks, and are used only for identification and explanation without intent to infringe.

Library of Congress Cataloging-in-Publication Data
Miles, Dean.
 Location audio simplified : capturing your audio . . . and your audience / authored by Dean Miles.
 pages cm
 1. Sound in motion pictures. 2. Sound—Recording and reproducing. 3. Motion pictures—Sound effects. I. Title.
 TR897.M55 2014
 777'.53—dc23
 2014002606

ISBN: 978-1-138-01877-8 (pbk)
ISBN: 978-1-315-85846-3 (ebk)

Typeset in Helvetica
by Apex CoVantage, LLC

Printed and bound in the United States of America by Sheridan Books, Inc. (a Sheridan Group Company).

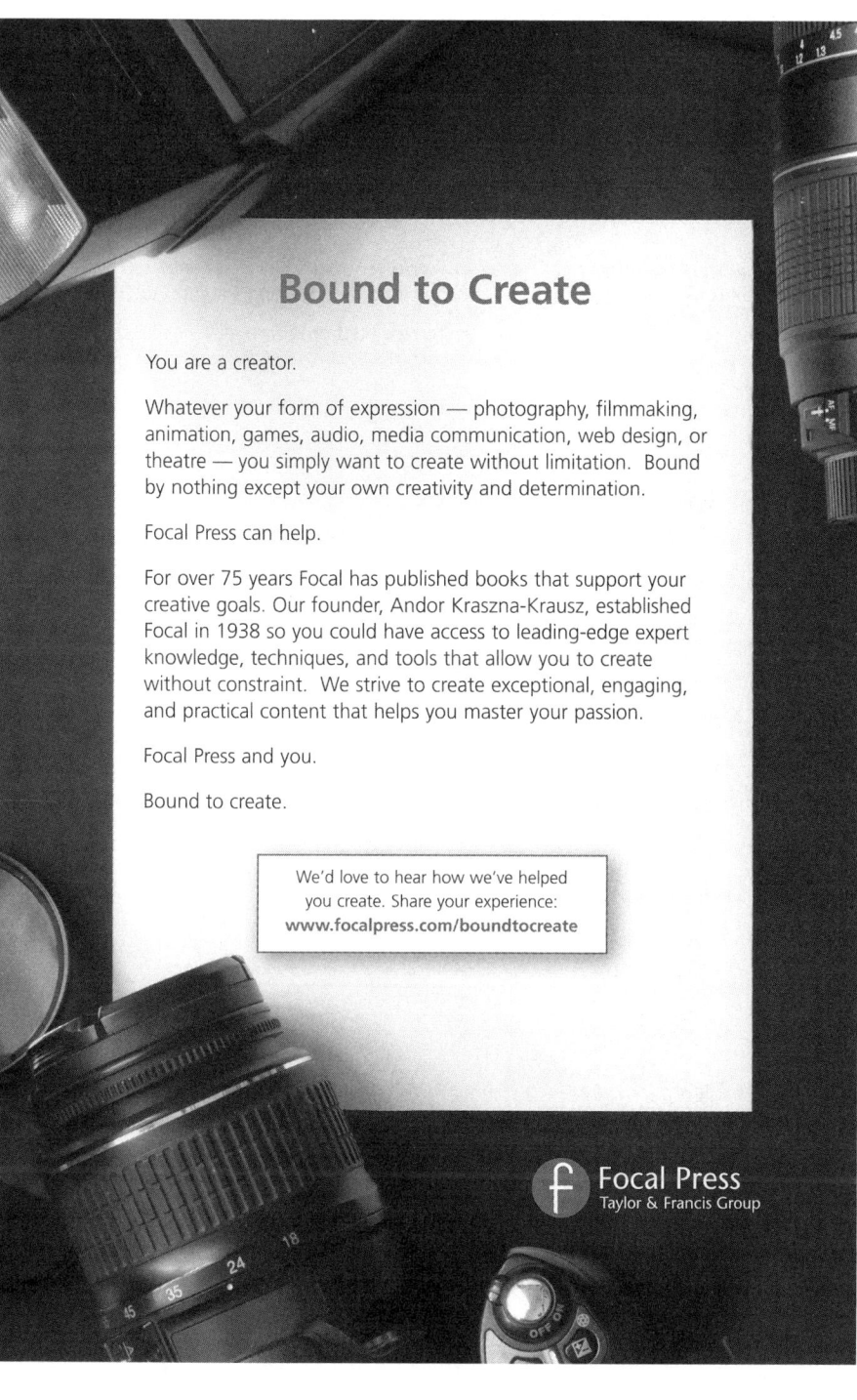

Dedication

This book is dedicated to all my students. They urged me to write it, helped shape it, and taught me how to teach. Without them this book would not exist.

Contents

Acknowledgements	xiii
1 Introduction to Location Audio	**1**
Introduction	1
Detailing the Professional	3
What Is Location Audio?	3
What Makes a Successful Location Audio Operator?	4
More Than Just Sound	4
Companion Location Audio Online Course	5
2 Choosing and Preparing a Location	**6**
Constant Tug-of-War	6
Choosing a Location	7
Five Steps for Choosing a Location	7
Preparing a Location for Recording	17
How Much Ambience Is Too Much?	19
Making a Location Move	21
3 Location Audio Field Mixer	**22**
The Field Mixer	22
Features of the Field Mixer	23
Initial Setup Procedure for a Field Mixer	33
Field Mixer Initial Setup: Four-Channel Field Mixer	33
Recording a Safety Track	35
Putting It All Together	37
Tying into the Camera	46
Connecting a Shotgun Mic	49
Connecting a Wireless System	49
Professional Impression	50
4 Field Mixer Operating Techniques	**52**
My Guarantee to You!	52
Operating and Monitoring Techniques	52
Task #1—Assigning/Panning	53
Task #2—Dialing In	58
Task #3—Monitoring Function	71

	Task #4—Listening	78
	Task #5—Shooting	85
	Room Tone Is a Must!	88
5	**Shotgun Microphones**	**90**
	There Is No Other!	90
	Shotgun Microphones: Characteristics and Groups	92
	Group 1: Hyper-Cardioid Microphones	92
	Group 2: Short Shotgun Microphones	94
	Group 3: Medium Shotgun Microphones	94
	Group 4: Shotgun Microphones	95
	Pick-up Pattern Width	96
	Powering a Shotgun Mic	97
	Low-Cut Filter on a Shotgun	98
	Axis and Lobeing	99
	One Final Thought	101
6	**How to Boom**	**103**
	A Booming Introduction	103
	Prepping and Wrapping the Boom Pole	104
	Operating the Boom Pole	110
	Static and Motion Booming	116
	One-Hand Booming	120
	Never Pass Through the Axis!	122
	Booming the Sweet Spot	123
	Scooping	125
	Booming Quick List	126
7	**Lavalier Microphones**	**127**
	The Lavalier	127
	Lavalier Basics	127
	When to Use Lavalier Microphones	129
	Lavalier Design Types	134
	Applying a Lavalier	135
	Exposed Micing Technique	137
	Hidden Micing Techniques	143
	Lavalier Techniques: Micing on the Head	153
	Hiding a Top-Loaded Lavalier	154
8	**Wireless Systems**	**160**
	Wireless Introduction	160
	Wireless Basics	162
	Setting Up a Wireless System	165
	Calibrating the Receiver to a Field Mixer	168
	Calibrating the Receiver to a Video Camera	172
	Wireless Hop	174

CONTENTS

9	**Video Cameras**	**178**
	Video Cameras	178
	Common Video Camera Functions	180
	Camera Calibration	185
	The VJ Attenuator	188
	Direct Microphone Input	190
	Professional Field Mixer Input	192
	Always Check Your First Recording!	197
	Consumer and Professional Line Level	198
	Label Video Tapes?	198
10	**DSLR Cameras**	**200**
	DSLR Cameras	200
	This Not a Cop-Out!	201
	The DSLR Camera Mic	201
	Onboard Camera Mic Setup	203
	Keeping in Sync	205
11	**The Field Recorder**	**208**
	The Field Recorder	208
	Thanks DSLRs!	209
	Portable Digital Audio Recorders	209
	Calibrating Your Mixer to a Portable Field Recorder	211
	The Future of the Field Recorder	214
12	**The Interview**	**215**
	The Interview	215
	Who's Decision Is It?	215
	Here's How You'll Conduct the Interview Process	216
	The Long Overdue Meeting	217
	Nonverbal Communication	218
	Be Prepared	219
	Conclusion	220
13	**Add-Ons**	**221**
	Handheld Microphone	221
	Microphone Flasher	223
	Wireless Monitoring	223
	Must-Have Accessories	224
	Happy Recordings!	226
	Index	**227**

Acknowledgements

I wish to acknowledge my long-time video colleague and friend, Scot McDonald, who faithfully allowed me to road test many of my operating techniques, and whose feedback was invaluable. His help and guidance through the long haul of writing this book was unwavering. A big thanks to Matt Lapham for all his help and expertise in the video industry. I appreciate everything you've done. My friends, Shawn Mabey, Peter and Jen Frisk, Christabelle Kux-Kardos, Joanna Gyurkovics, and Jean Michel Landry, who all donated time and beautiful faces to my book. And finally, my loving wife, Ann, who encouraged and supported me every step of the way to be true to my accomplishments.

A special thanks to Davida Rochman and Robin Dwyer at Shure for supporting my efforts to teach location sound.

There are many location audio operators, camera operators, retailers, and co-workers in the various video departments I haven't mentioned who have influenced my career, some positive and some negative. We learn, we teach, and hopefully it's an exciting ride.

CHAPTER 1

Introduction to Location Audio

Introduction
Detailing the Professional
What Is Location Audio?
What Makes a Successful Location Audio Operator?
More Than Just Sound
Companion Location Audio Online Course

Introduction

Congratulations!

Figure 1.1

You've picked up my book and are already one step closer to recording better audio in the field. Now just buy the damn thing and let's get started.

The new era of affordable digital video has created a boom in the production industry. Cameras are smaller, cheaper, easier to use, and provide amazing picture quality. However, the audio side of the equation is a different story. Sound tends to be the poor cousin to the visual image, and most manufacturers give it minimal consideration at best. The actual hardware components are of marginal quality, controls are buried in submenus, and connectors are stuck onto camera bodies like an afterthought. The video world is littered with videographers and location audio operators who are being driven crazy trying to produce quality sound in this environment.

Location Audio Simplified will do just what it says: simplify the location audio process.

INTRODUCTION TO LOCATION AUDIO

Figure 1.2

Figure 1.3

Whether it's big-budget documentaries or low-budget corporate videos, the principles of quality audio remain the same. From the basics of using camera, handheld, lavalier, and wireless microphones to camera calibration and mixer set-ups, *Location Audio Simplified* helps unlock the secrets to clean, clear, broadcast quality audio no matter what challenges you're faced with. Nothing will ruin a viewer's experience faster than incomprehensible dialogue due to incorrect micing techniques or distracting background sound from a poor location choice.

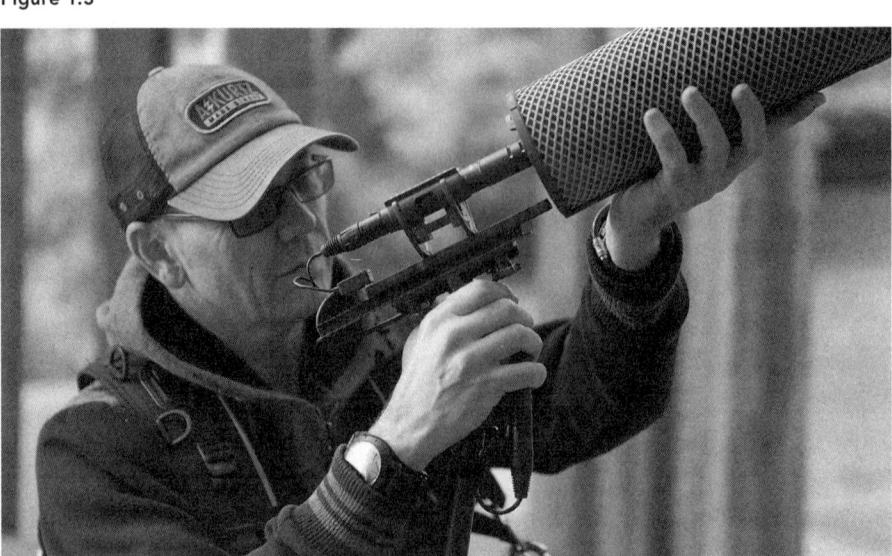

Figure 1.4

Detailing the Professional

Since 1989, I've been working as a professional location audio operator for major television networks, motion pictures, high-end documentaries, and everything in between. Through it all I've encountered every sound problem imaginable and have developed my own tried-and-true solutions, techniques, and easy-to-follow tricks and tips.

When I first penned *Location Audio Simplified* in 2006 I had no idea there were so many location sound operators working and battling with the same sound issues as I was. The emails thanking, questioning, and teaching me have made the arduous task of writing a book worthwhile.

If you're an up-and-coming location sound pro, you'll find everything you need to build a foundation for a successful career. If you're a one-man-band camera operator, you'll learn how to elevate your sound from average to exceptional.

If poor sound is plaguing your productions, this is the book for you.

What Is Location Audio?

In a nutshell, location audio is the recording of sound outside of the controlled and comfortable confines of a studio. A video location audio operator is a one-person sound department responsible for capturing all the required dialogue, ambience, and sound effects necessary to build a rich soundtrack in postproduction.

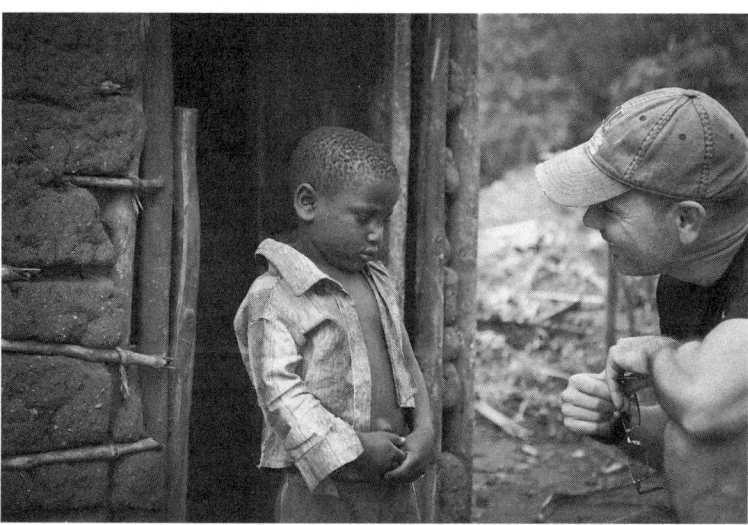

Figure 1.5

What Makes a Successful Location Audio Operator?

The skills required for location audio are a mixture of technical skill, experience, common sense, and attitude. A successful operator is confident, professional, adaptable, and most importantly, a team player with a positive outlook. Simply put, if you do a good job and people enjoy working with you, you'll be busy. Whatever your technical ability, if you're a pain in the butt to work with your career will be short-lived.

Location audio involves balancing many issues, both technical and practical, and understanding how you affect the pace of the shooting day and even the overall experience of the talent and crew. Your primary responsibility is to capture clean dialogue and appropriate ambience and record it with minimum disruption to the production process. A job well done often means people aren't even aware you're doing it. Where they'll notice your work is in the edit suite.

Making the post audio editor's job easier goes a long way towards building a good name for yourself.

More Than Just Sound

Setting up lights, helping with props, loading and unloading equipment—you'll be doing anything that needs to be done. By becoming an invaluable member of a production team, clients will not only respect your skills as an audio operator and value your opinion but will also put your name at the top of their call list.

As your clientele increases, so will your opportunities, challenges, and adventures. You'll be on your way to a rich and rewarding career in the production industry—not to mention looking extremely cool with all that gear strapped to your body like a SWAT team member.

I hope you find it easy to move forward through this book and find it a valuable tool in learning how to record quality location audio.

In the world of video production, location audio operators are also expected to pitch in and help wherever they can.

INTRODUCTION TO LOCATION AUDIO

Figure 1.6

Companion Location Audio Online Course

To help learn the techniques detailed in this book, I've created the "Location Audio Simplified On-Demand" course: 37 classes and over six hours of online instruction bring every technique, theory, concept, and skill in this book to life. Together, the *Location Audio Simplified* book and the Location Audio Simplified On-Demand course will have you well on your way to a successful career in location sound.

To view the trailer and sign up for the course, go to:

https://vimeo.com/ondemand/locationaudiosimplified.

CHAPTER 2

Choosing and Preparing a Location

Constant Tug-of-War
Five Steps for Choosing a Location
Preparing a Location for Recording
How Much Ambience Is Too Much?
Making a Location Move

Constant Tug-of-War

Since sound joined moving pictures on location, the audio operator has never had a say regarding location, and has had to fight for every inch of sound improvement—but that's about to change.

The picture has always been the decision maker when it comes to choosing the location, even when dialogue was being recorded. I've heard the comments "Hey, it's a visual medium," and "Maybe you should work in radio," so many times that I was preparing to stick their medium where the sun didn't shine! Because of ADR (automatic dialogue replacement) and large post budgets, any dialogue problem could be repaired, and therefore you just smiled, rubbed your bruised audio ego, and recorded guide track. Well, this attitude does not work in video, and it surprises me that this "Old Boy" film attitude found a home in the video world.

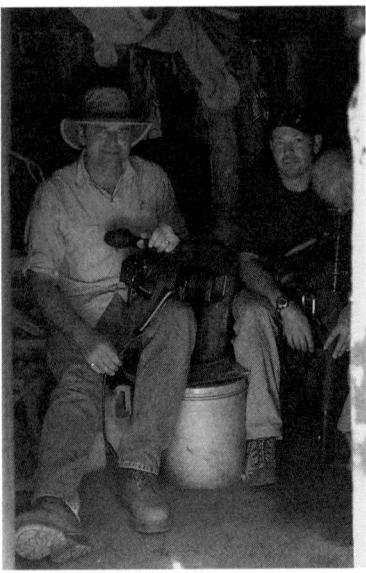

Figure 2.1 Choosing a poor location to record dialogue is just shooting yourself in the foot!

How can anyone expect to record usable dialogue in a noisy environment! For years I was forced to record in locations where it just wasn't possible. Camera operators, even interviewers were the decision makers when it came time to choose locations to record critical audio!

Why should I defer to someone who isn't going to take the heat if the audio is unusable!

IT WAS TIME FOR A CHANGE

Choosing a location when recording dialogue should never be based on pictures alone. As directors are exposed to the ramifications of poor location audio, priority is often given to the sound operator on many shots—you need to have the tools to make an educated decision regarding possible location sound issues.

INSIDE THE AUDIO GUY'S HEAD

"No one's listening to a thing I'm saying."

"The camera operator doesn't care if the sound sucks!"

"I'm nervous about talking to the director."

"Stop complaining. This is the job, just deal with it!"

How many times did these thoughts cross my mind? Well, quite a lot actually. But when I decided to take control and be responsible for any sound issues that may arise when I'm on set, I realized I needed some kind of information-gathering tool and a way to communicate these findings with the person responsible for the entire production.

I eventually figured out how to overcome these fears and maneuver the shark-infested waters of a set—and the solution was actually quite simple.

Choosing a Location

Choosing a shooting location that works for both picture and sound is no easy task. For a video production to come together there needs to be compromise.

I've developed a five-step fact-gathering procedure to identify and minimize sound issues that could cause delays during shooting and/or costly fixes in post.

These facts, when presented to the decision maker in a concise, informative way (no complaining or whining) were quickly accepted and, to my surprise, very effective in solving most location sound woes!

The five-step process that follows is absolutely vital to quality field recordings! *Do not* blow over this section—understand how to apply it.

Five Steps for Choosing a Location

1. Understand the purpose of the material being shot.
2. Determine if the sound will match the image.
3. Identify potential sound problems that could cause disruptions.

CHOOSING AND PREPARING A LOCATION

4. Assess the general ambience of the location.
5. Communicate your concerns and recommendations with the decision maker if required.

Be warned—most camera operators consider audio a distracting annoyance. It's all about pretty pictures.

STEP 1 *Ask the right questions to understand the purpose of the material being shot.*

You need to have an understanding and a sense of context for the project you're working on to help determine what sound issues are relevant.

Ask for a brief overview of the production, the intended audience, where it will be shown, how long the finished piece will be, etc. This helps you anticipate what will be happening during the course of the shoot, and you'll know how the disjointed elements fit together.

The sound can be used for many different purposes and isn't necessarily always married to the image. Most importantly, it will give you a framework to decide whether to be obsessively picky or to just get the shot in the can.

Before you arrive at every location, get in the habit of asking whoever's wearing the director's cap this question:

Q "What are we shooting next?"

The answer will fall into one of the following five shot types and will dictate how much, or how little, information gathering you'll need to do.

SHOT TYPE #1. B-REEL

B-reel is also called b-roll, cutaways, filler, or pictures only. Basically, it means that the audio isn't critical and will be edited with other sound tracks, music, and/or used as low-level ambient sound only.

Figure 2.2 B-reel—always have sound on every shot.

CHOOSING AND PREPARING A LOCATION

However, this shouldn't mean there isn't any audio at all—even if the camera operator wants to run off with the camera and "just grab a few shots." There's nothing more unprofessional than material recorded without audio. Always give the editors something to work with. They can always delete it but can't always recreate what's not there.

For most b-reel shooting, the camera-mounted mic does the job just fine. Make the appropriate audio adjustments to the camera to record with the camera-mounted mic before they head off to shoot b-reel. And make absolute sure to recalibrate the audio settings on the camera when you reconnect your mixer. Don't rely on the camera op to make these audio adjustments for you.

SHOT TYPE #2. STAND-UPS

Stand-up is a term that originated in the news industry. Simply put, it's a person standing there talking directly to camera. Typically, stand-ups will be an intro for a program, a transition to a new topic or scene, or a quick wrap-up.

Figure 2.3 Stand-up shot

Since they're generally short in length and the audio will never be separated from the picture, you can usually allow a high level of background noise and changes in the ambience bed, such as traffic on a busy street or a crowd at a football game.

The trick is to make sure you can hear the dialogue clearly, and the camera is seeing what is creating the noise so it makes sense—more on this later.

SHOT TYPE #3. SCENE OR SEQUENCE

This is when you're shooting several shots at a location that will be edited together to form a seamless sequence. The entire sequence is typically called a scene. For example:

Shot 1 (Medium shot): A man puts on his coat and grabs his brief case inside the front door of his home.

Shot 2 (Wide shot—slow pan): From outside we see the door open, and he walks to his car in the driveway.

Shot 3 (Close-up): His keys go into the lock and the door opens.

Shot 4 (Medium shot): Interior of car from passenger seat as he gets in and starts the car.

Shot 5 (Wide shot): Man drives off in car. Car exits frame.

Each shot produces its own set of audio challenges. But they need to connect together and appear to be a continuous moment in time. Having a siren or dogs barking in the background on one angle but not in another will be a problem. Gathering solid ambience beds will dramatically improve the flow of the scene.

SHOT TYPE #4. INTERVIEW

We all know what an interview is. They can be short, five minutes, or very long—like the dreaded two-hour marathon. They will probably be heavily edited and placed over b-reel.

It's best to think of the interview as being primary voice-over. A great deal of the interview content will be used as narration over b-reel, with only an occasional shot of the person in the interview setting.

Figure 2.4 Formal sit-down interview

CHOOSING AND PREPARING A LOCATION

Audio for interviews needs to be as clean and free of distracting background sounds as possible. You just don't know where it will end up in the final product—or in what order.

Even moderate background sounds that come and go over a long period of time can be problematic. For example, when an editor selects a clip from the 30-minute point of an interview when the air conditioner is running and tries to connect it with another clip from the first 5 minutes when the air conditioner was off, it can be difficult to create a smooth audio edit.

SHOT TYPE #5. VOICE-OVER OR VO

Often you'll be asked to record narration in the field rather than the talent going into a sound studio. This is becoming more and more common, as it reduces production costs and saves time for the producer. It can range from small pick-ups to entire scripts, and the sound you record won't be married to any picture at all.

Figure 2.5 A vehicle can make a great VO booth.

On many shoots you'll be recording sound directly to the camera. If you use the camera as the recorder, it's good practice for the camera to shoot something during the VO. I recommend you ask the camera operator to shoot a general wide shot of the talent reading the script, so there's no mistaking what it is when the editor is digitizing. Having the camera operator shoot pretty flowers or landscapes as you record your voice-over leads to no end of confusion in the edit suite.

CHOOSING AND PREPARING A LOCATION

Figure 2.6 VOs are often shot on location.

In my experience, recording voice-overs always seems to be the last thing that needs to be done at the end of the day. Everyone is tired and just wants to get it over with. You'll need to resist the pressure to rush through it and be vigilant about getting what you know you need. A warning: They might get a little annoyed with you on location, but they'll love you in the edit suite.

Because pictures aren't important here, you have the power to choose what location works best for sound. Recording clean, ambience-free dialogue—and I stress ambience-free—is the number-one priority when recording a voice-over.

STEP 2 *Determine if the sound will match the image.*

Q "Does the sound match the shot?"

It will amaze you how often this simple check will expose one of the most common mistakes made by location audio operators. Take your time here. Be critical. It can become a major issue in post if the picture and sound are at odds.

Make sure that the sound of the location works with the shot the camera operator has framed. What a viewer sees in the frame will lead to their expectations of what they should be hearing. A person standing on a busy street corner makes sense with loud traffic sounds.

If the camera is moved so that the traffic is eliminated from the frame and the viewer sees only a park bench and green grass on the other side, traffic noise is distracting and seems at odds with the image. Same location—completely different expectations.

CHOOSING AND PREPARING A LOCATION

It's important to understand that the editors only hear and see what was shot. They won't know all the variables that brought you to the location, or the reasons why the recorded sound is the way it is. They have no idea what was happening all around the framed shot. It's your responsibility to make sure that the sound makes sense with the picture.

Figure 2.7 Imagine if this shot had an ambience of children playing at school.

To determine whether the sound will match the shot, ask the camera operator what he or she has in mind for the framing, or look in the viewfinder. With that picture in your mind, close your eyes and decide if what you are hearing matches what the camera will be seeing.

If you determine the sound will not match and it will be distracting, often the most effective solution is to discuss the situation with the camera operator. If possible, suggest including the source of the background noise in the frame so everything makes sense. Seeing a water fountain or heavy street traffic in the distance behind the subject now "justifies" the sound.

STEP 3 *Assess the location and identify potential problems that could cause disruptions.*

When you arrive at a location you need to begin by evaluating the ambience. Use your eyes and ears, and talk to the occupant of the location about potential sound problems.

Q "Are there any extraneous sounds?"

Unexpected sounds that come out of nowhere will cause nothing but grief. A dog barking, a car's alarm going off, a telephone ringing—all generally lead to stopping and disrupting the flow of the shoot.

13

CHOOSING AND PREPARING A LOCATION

Figure 2.8 Didn't see that coming!

Some things are just beyond your control and there's not much you can do about it, but in my opinion the majority of extraneous sounds that occur while recording can be prevented.

Here's a typical example: After we've arrived on location, the hellos are done, and the director, camera operator, and I discuss the content and context of the shoot (Step 1). Let's say it's an interview with an architect at his residence, so the camera operator and I scout the location for the exact position we'll be shooting.

The camera operator likes the look of the living room and proposes a medium shot of the subject in a chair with a portion of the fireplace and a window in the background. I close my eyes and listen to the general ambience of the room (Step 2). I determine that it sounds like a warm living room setting. A slight amount of outdoor sound also works, as we'll be seeing outside through the window in the shot.

I then break off and start collecting a list of potential problems (Step 3): a refrigerator turning on and off, a water cooler humming, a computer fan, a radio playing in the kitchen, and so on. Normally these can be easily solved by unplugging the refrigerator or water cooler then asking the subject for permission to turn off the computer, radio, and telephone.

TIP! If you do turn off a refrigerator, place you car keys inside and close the door. When it comes time to pack up and leave, you aren't going anywhere without them. "Hey, where are my keys? Oh right!"

Next, I see if there are any extraneous sounds coming from outside that may or may not be difficult to control. I look outside and see a bus stop and a neighbor who is mowing his lawn. More often than not, I can quickly talk with the neighbor, and he'll be fine

stopping for an hour or so—problem solved. However, after talking to the architect, I find that the bus stops right outside every 12 minutes or so. Not much I can do about the bus. We may have a problem with it.

I know I can deal with all the sound concerns except for the bus. So, I make a mental note that I will have to discuss it with the decision maker. I'd continue assessing the location with Step 4.

Don't bother the decision maker with all the extraneous sounds you will deal with. Keep it to yourself—it's just part of your routine.

Taking the time to identify extraneous sounds will go a long way in preventing disruptions to the shooting day. Constant "stop-tape" interruptions while you try and figure out "where that noise is coming from" will only serve to create tension and stress for everyone.

There are locations where extraneous sounds will render the location unusable for recording sound. It's better to know this before you start shooting.

Time for one final critical listen. Take a few minutes and listen closely for subtle ambience changes: refrigerators, a CPU whirring up, a furnace or AC, outside traffic, etc.

STEP 4 *Assess the quality and consistency of the general ambience of the location.*

Q "Can the ambience be edited?"

In this final step, you assess whether the ambience can produce seamless audio edits. When shooting an interview, scene, or sequence, it's essential the ambience is constant in volume, consistent in sound elements, and not too loud.

Since you have no idea how extensively any given clip will be edited, the ambience needs to be stable. If the location has ambience that is constantly changing in overall volume or the types of sounds involved, it becomes extremely difficult and costly to deal with during postproduction.

For example: During an interview, a two-minute stretch of a refrigerator turning on could be popping in and out everywhere if the editor chops that section into smaller clips and intercuts it with other sections that are perfectly clean.

It's not necessary to worry about subtle changes in the ambience when shooting b-reel or stand-ups, but Step 4 becomes critical when shooting scenes or sequences, or interviews.

It's now time to communicate. Gather your facts and inform the decision maker of potential problems.

Knowing when and where it's appropriate to discuss location issues is a bit of an art, but in time it will become just another part of your day. If you're overzealous about

CHOOSING AND PREPARING A LOCATION

sharing every little concern or complaint about a location, you'll be known as the typical whiney audio operator who hates everything. You won't exactly be the life of the party.

STEP 5 Communicate your concerns and recommendations with the decision maker if required.

If you do it right, you'll be helping the shooting day move forward with fewer delays and in a much more relaxed way. You'll be quietly working under the radar, solving problems the rest of the crew didn't even know existed.

It's a very rare day to find a perfect location. All will have their quirks and challenges. Being able to work as part of the production team to keep the shooting day moving forward will be much appreciated. Digging in your heels and criticizing will get you nowhere.

Here are a few tips to aid in your discussions with the decision maker:

- Never burden the decision makers about audio concerns that you can and will rectify. They have enough on their plate. The time to involve them is when decisions need to be made about issues out of your control that are significant enough to affect the quality of the sound.

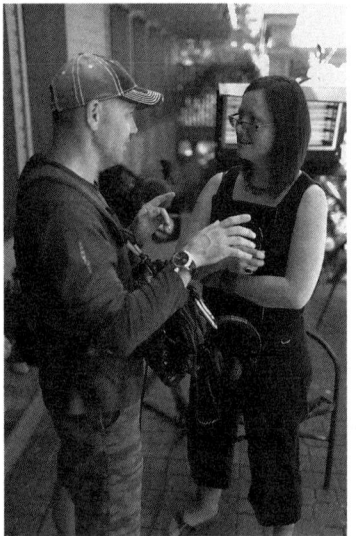

Figure 2.9

Constant unexpected interruptions caused by sound will grind a shoot to a halt and create much frustration.

- Be prepared to put the problem into context. Just saying the background is noisy isn't enough information. Say something like: "I can hear the dialogue clearly, but there is extensive background sound close to the window. The louder trucks and buses will definitely cause delays, and the cars could cause issues in post."
- Never recommend or suggest a solution unless asked. Just supply the decision makers with the concerns and let them make a decision: "I was talking to the architect, and he tells me that a bus passes by or stops out front every 12 minutes. The dialogue will be unusable when this happens—what do you think?"
- Never assume you know all there is to know about a shoot. There are all kinds of reasons why a location may have been chosen or why a producer or director may

choose one option over another—even if it doesn't seem to be the best choice. Time factors, availability of talent, budget constraints—they all play a role, and they may not choose to share them with you.

- Keep your opinions to yourself, even if you see a train wreck about to happen! You are the location audio operator—remember that! This procedure, if not used wisely, has the potential to blow up in your face if you overstep your role as a sound operator. You are not the director, or the producer, or the dialogue editor. Keep your opinions to yourself unless asked.

MAKE A DIFFERENCE

When these five steps for choosing a location are used correctly, you will be influencing a shooting day in ways that most directors will not be accustomed to, but they'll be pleasantly appreciative. Your attention and concern regarding their production, and the positive result your professionalism brings to the finished product, will be highly valued.

Never leave a location with questionable or unusable audio—it's not acceptable!

Watch Class 1—"Choosing a Location" of the Location Audio Simplified online course.

Preparing a Location for Recording

You've probably heard the comment "We'll fix it in post." If you're on a film shoot with a heavy audio postproduction budget, then almost anything is possible. But in video, what you record on location is pretty much what's going to end up in the final product.

Preparing your location is vital to recording quality tracks. Crossing your fingers and hoping your tracks will be clean will not pay off in the long run. If there's an extraneous sound within your mic's range, it's gonna get you!

To prepare a location, you need to identify and deal with any extraneous sounds, ambiences, and potential sound problems that will compete with the dialogue you're trying to capture. It's not necessary to void the location of all noise, shoot all things with feathers, and create a vacuum. Your goal when prepping a location is to ensure the background ambience matches what the camera is seeing and unwanted sounds don't create distractions.

CHOOSING AND PREPARING A LOCATION

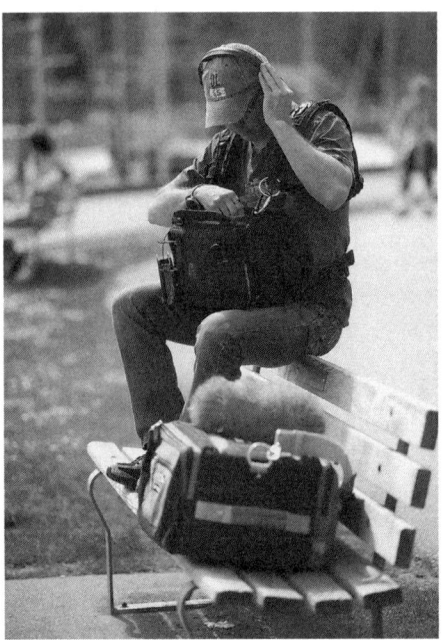

Figure 2.10

BEFORE YOU BREAK OUT YOUR GEAR

First you want to take care of extraneous sounds that could render a location unusable. Then you want to eliminate or move away from sounds that are heavy in the frequencies of the human voice—such as AC, fans, and traffic. Sizzly, poppy, sharp high-frequency sounds like cicadas and grasshoppers, wind, rustling leaves—these all strongly compete with dialogue. You need to pay close attention when they are present in your location. Then make sure sounds that can be "On" and "Off" for long periods of time are turned off—refrigerators, computers, furnaces.

Sounds that are in the lower bass frequencies (like a low rumble in a factory) are not as troublesome since you can easily cut them out with your audio mixer's high-pass filter.

This ain't rocket science, but you need to be diligent.

Most location sound troublemakers can easily be dealt with by unplugging, turning off, or removing them from the immediate location. Listen for sounds that require time to resolve or could be beyond your control. It's usually possible to ask the neighbor across the street to put down the leaf blower for an hour, but it may require some subtle diplomatic skills. Most importantly, you need to determine if there are any major problems you can't eliminate that will render the location useless. There's not much you can do about a barking dog next door if you discover nobody is home.

After I've prepped the location, I'll separate myself from the crew for one final evaluation. This may seem a little over the top, but I take sound disruptions to the day personally! I'm not doing my job if I'm chasing a chicken down the road with all my gear on.

COMMON TROUBLEMAKERS

Nearby construction, furnaces, air conditioners, telephones, cell phones, refrigerators, freezers, computers, radios, televisions, water coolers, vending machines, door chimes, ticking clocks, squeaky chairs, pets—there's a long list of troublemakers ready to wreak havoc with your otherwise problem-free shoot.

CHOOSING AND PREPARING A LOCATION

Figure 2.11

Sometimes the noise-makers come with the talent—jingly jewellery, or objects in their hands such as pens, paper, and gum wrapper are typical offenders. Inform the talent that rubbing their hands on their pants or shuffling their feet can also cause audio problems.

Notify all occupants of video in progress, and place a sign on exterior and bathroom doors if necessary. Close all windows and doors.

Not dealing with these issues and hoping for the best will prove to be extremely frustrating and will often bring a shoot to a standstill. It's also very unsettling for on-camera talent or the subject of a documentary-style interview to have to constantly stop and wait for the sound to clear.

Watch Class 2—"Preparing the Location."

How Much Ambience Is Too Much?

Ambience is not necessarily a bad thing. It adds energy and life to a location. But knowing whether it's going to ruin or enhance your recording takes time to learn.

Dialogue should always sit on top or be forward of the background sounds. There should be no competition from the ambience for the viewer's attention. The saving grace with ambience is it will often take care of itself. In loud locations, people talk louder. When the camera is further away, talent will usually project more. So everything should take care of itself if you choose and prep the location properly.

But we know this isn't always the case. It gets confusing when the ambience is at odds with your frame, or you're trying to record as ambient-free as possible.

When you run into situations where there are sounds that seem too loud or there's an ambience that you deem to be competing with the dialogue, you'll need to put your gear on and get a mic in the shot. You want to do this before the crew starts setting up and readying the location to shoot.

Your headphones and microphone are going to complicate matters at this time by accentuating some sounds and losing others. You'll find that certain sounds are louder and more distracting through your mic than they are to the naked ear, and vice versa. Microphones don't have the ability to ignore a sound that's unimportant to the clarity of dialogue.

To make sure you have enough separation between the dialogue and ambience, first get talent to speak at performance volume and look at your meters. Make sure that when the talent speaks there's a noticeable increase of level. Depending on the type of shot (stand-up versus interview) and the location (boardroom versus rock concert) the minimum acceptable separation can vary from 30dB to 16dB.

If I'm concerned about separation with my gear on, I'll record some talking if I have my own recorder or ask the camera op to record a take and listen to a playback.

"Hey . . . You can't do that! We don't have time for you to check audio!"

Anyone who has been on location knows this isn't an easy task. The general indifference by the rest of the crew towards the needs of the sound operator will result in a chorus of groans and rolling eyes about this request. But you've got to do what you've got to do.

Listen to the playback and decide whether the possible offending ambience is distracting. If I'm unsure, I won't hesitate to ask the camera operator for his or her opinion. Make your decision, and prepare the location further if needed. Do not fold like a cheap lawn chair if you are being questioned or given that disgusted look from members of your crew. Get it right—your career depends on it.

Now, here's the scariest thing you'll ever do in your entire location sound career. If you know the location is a bust and the tracks are unusable, get the information to the decision maker as soon as possible and request a move. *Do it!* If it ain't workin', it ain't workin'! It's not going to magically fix itself! You're not getting paid to record unusable tracks. Don't wait until setup is complete and you've started shooting, this will just make matters worse! Be proactive and bring the sound issue to the attention of the decision maker.

A location sound op I worked with had the perfect phrase: *"Love me now and hate me later, or hate me now and love me later"*—it rings very true!

Watch Class 3—"Understanding Dialogue and Ambience Separation."

ASSUME THE WORST!

The commitment and technical ability of video producers towards quality audio throughout the production process is as wildly erratic as the content of their projects.

From camera operator/producers editing on their laptops, to knock-your-socks-off edit suites that George Lucas would feel comfortable in, you just never know where or how your sound will be dealt with. Assume the worst.

Making a Location Move

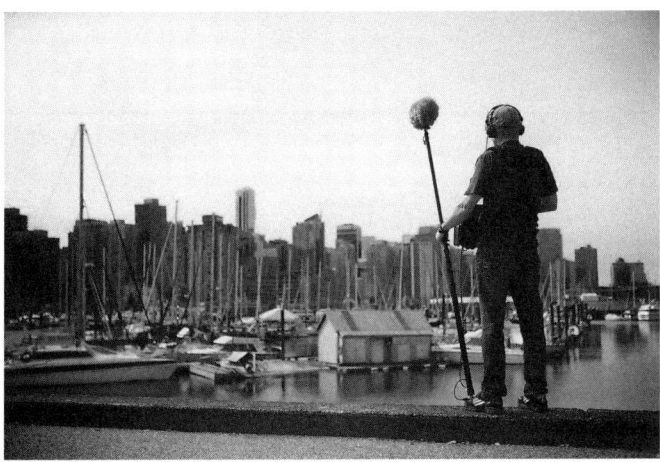

Figure 2.12

When I talk about moving to an audio friendly location, I don't mean taking an interview from a downtown office building to a farm pasture in the country. Most times a location move is a very subtle one: moving from one end of the kitchen to the other because of an echo problem; using the back yard rather than the front yard to avoid street noise; using a different office on the same floor to get away from noisy air conditioning that can't be turned off. Even something as simple as having the talent face a different direction can make a dramatic difference. The easier the move, the more chance it will happen.

Be prepared for *"Where do you suggest we go?"* Either have another location in mind, or be ready to scout out another location with the camera operator. Always include the camera operator when scouting for another location, even if you've already found one. Involving the camera operator is a must; you've probably ruffled his or her feathers.

Most camera operators will be unaccustomed to having their location choice questioned, especially from a sound person. Don't waste your breath trying to explain the audio problem, just describe what needs to change to solve it.

The decision to move a location needs to be made by the director, not by the location sound operator.

CHAPTER 3

Location Audio Field Mixer

The Field Mixer
Features of the Field Mixer
Initial Setup Procedure for a Field Mixer
Recording a Safety Track
Putting It All Together
Tying into the Camera
Connecting a Shotgun Mic
Connecting a Wireless System
Professional Impression

The Field Mixer

The location audio field mixer is the core of every sound operator's equipment package. This is not the place to cut corners or make do with a piece of gear that isn't up to the task. A field mixer needs to withstand an enormous amount of abuse and keep on performing flawlessly. From African deserts to Alaskan ice fields, it just has to work.

Field mixers are in constant evolution and will continue to be as technology tries to make them smaller, more efficient, and less expensive. But beware: make sure features like high-pass filters, a tone oscillator, and quality limiters are on your next mixer.

Take your time when purchasing. As with all expensive pieces of equipment, try it out or rent before you buy.

LOCATION AUDIO FIELD MIXER

Figure 3.1

Features of the Field Mixer

Mixers come in various configurations but they all work the same way. As you'll see, some mixers are a little more complicated than others, but we're going to keep it simple and focus on learning the basic functions that all field mixers share. If you're familiar with the field mixer, you might still want to read over this section. There are a couple of things that might make you say, "mmm, that's cool!"

Figure 3.2

23

LOCATION AUDIO FIELD MIXER

Figure 3.3 Mixer input section

Figure 3.4 Mixer output section

POWER SWITCH AND BATTERIES (1)

The power "On/Off" switch on most field mixers will be a three-way switch made up of the following settings:

Internal Power—the mixer is powered by batteries you install in the mixer.

Figure 3.5 Internal power supply

LOCATION AUDIO FIELD MIXER

Figure 3.6 External power supply

Off—the mixer shutdown.

External Power—an external battery source or AC/DC converter.

There are some very nice (expensive) rechargeable external battery systems that will power your mixer and wireless systems at the same time. But most operators tend to use the internal batteries. When using the internal battery system, always ensure you are well stocked. Running out of battery power during a shoot is just not acceptable.

I'm not a fan of rechargeable "AA" batteries. Changing batteries two to three times a day opens me up to a possible mistake. But if you're going to use them I suggest NiMH rechargeable batteries.

Since the mixer's sound quality is 100 percent dependent on battery power, it's best to err on the side of caution when replacing batteries. Even though the mixer I use will comfortably run for 14 hours (when using one phantom-powered mic), I never exceed 8 hours. On some mixers, as the battery power weakens the sound quality slowly degrades. The mixer will begin to hiss, but so gradually that you may not notice it until it's too late.

CHANNEL FADER (2)

The channel fader is used to increase the level of signal (volume) passing through each channel of the mixer. Each channel has a dedicated fader that corresponds to its input.

LOCATION AUDIO FIELD MIXER

Think of the channel fader as the "fine-tuning" of the incoming audio volume. Depending on the mixer, you'll first adjust the "Channel Gain" or "Pre-Amp Attenuator" and then fine-tune the signal with the channel fader.

CHANNEL GAIN (3)

The channel gain is used to increase the level of signal (volume) entering each channel of the mixer. Each channel has a dedicated gain dial that corresponds to its input.

The channel gain can be thought of as "coarse" tuning. You first adjust the channel gain close to the desired amount of signal you want to enter the mixer, and then fine-tune the signal with the channel fader.

MASTER GAIN (4)

The master gain is used to increase and decrease the level of signal that exits the mixer. On all mixers, the master gain will have a "0" setting with a détente at the mixer's unity output setting to set it perfectly every time. (A *détente* is a notch so you can set it exactly every time.) This is a set-and-forget dial that you should avoid playing with.

METERS (5)

The meters are your visual representation of the sound as it passes through your mixer. They're also the source of no end of confusion about how they should be performing and where they should be peaking. Many an operator has stared at them in wonder—*"What the heck is going on?"*

Depending on the mixer, you could have one type of meter or the ability to switch and even mix various types of meters.

VU (volume units) and PPM (peak program meters) are the most common meters used in North America. PPM meters are very accurate and match just about every if not all digital cameras on the market today. VU meters were more common in the analog era and will give you more of an average level of the sound that is passing through your mixer. You'll need to pay close attention when calibrating to today's cameras while using a mixer with VU meters—I'll touch on this later.

Since the early 2000s most new video cameras (prosumer to pro) have PPM meters. They are the industry standard for metering, and your mixer should have them.

PRE-AMP ATTENUATOR (PAD) (6)

As sound enters your mixer from a mic, you need to make sure that it's at a level or volume the mixer can handle. The pre-amp attenuator or PAD function attenuates or decreases the incoming signal to a level that the mixer can work with effectively.

The PAD will have three settings: 0, –10, –20. Just by looking at the numbers you can tell it's going to decrease the signal.

Figure 3.7 Pre-amp attenuator (PAD)

The "0" setting won't do anything to the sound signal: it will allow the whole or total signal to enter the mixer. This is what we call *wide open*. Use this setting for dynamic mics, wireless and hard-wired lavaliers, and shotgun mics for most normal conversation levels.

The "–10" setting will attenuate or reduce the sound signal by 10dB (dB is the abbreviation for decibels and refers to the measurement of volume). If you're using very sensitive mics, or when the sound entering the mixer is loud (someone talking over traffic or in a factory, for example), you'd have to attenuate by –10dB to bring the volume down to a level the mixer can handle.

The "–20" setting will attenuate the sound signal by 20dB. An extremely loud location like a rock concert would require a –20dB PAD to control the incoming volume.

If your mixer uses Gain to control the input to your pre-amp you won't have a pre-amp attenuator.

HIGH-PASS FILTER (7)

Most mixers will have a high-pass filter (HPF), also called a low-cut filter. There are two types of high-pass filters found on mixers, stepped or sweepable.

LOCATION AUDIO FIELD MIXER

A stepped HPF will most commonly be a three-way switch with set frequencies like 20Hz, 100Hz, and 140Hz. With this type of HPF you choose the set frequency you want to cut at. The higher the number, the more bass you will remove.

Figure 3.8 Stepped high-pass filter

Sweepable HPFs are more accurate, since they use a rotary dial that can be increased or decreased at smaller increments.

Figure 3.9 Sweepable high-pass filter

LOCATION AUDIO FIELD MIXER

The purpose of the HPF function is to roll off or cut low frequencies that compete with the dialogue. When used properly, the high-pass filter is a powerful tool that brings clarity to your recordings and helps separate the dialogue from the ambience.

OUTPUT STAGE (8)

The output stage on a field mixer has two parts, the output select "Mic/Line" switches, and the physical connectors: XLR connectors, multi-pin video connector, and various 1/8-inch and TA3-type connectors for connecting to cameras, recorders, and wireless monitoring systems.

Figure 3.10 Output stage with XLR outputs

All mixers will have two XLR outputs (left and right) for sending the sound via two XLR cables to a recorder or camera. In addition, most will have a multi-pin video connector for a control cable that gives a second pair of outputs as well as a monitor return. I'll cover the multi-pin video connector and monitor return in a bit.

The output select switches are used to switch the XLR outputs and the camera out or multi-pin video connector to "Mic" or "Line" level. What this does is choose the final level of signal the mixer is going to send.

Think of this function as a matching game. If the camera or recorder requires a "Line" level input, you have to match it by switching the output select switches on the mixer to "Line" level.

Figure 3.11 Output stage with various outputs

The difference between mic level and line level is about 50dB. If you don't match the mixers output select to the camera or recorder's input select, the recording will be unusable. Most video cameras have an input select that is switchable between "Mic" and "Line" level, so matching is easy.

LIMITER (9)

Hopefully the mixer you own has a limiter. If it doesn't, put it in a paper bag, jump in your car, and toss it out the window. Since most cameras today are digital, you'd be crazy not to have the safety net of a limiter on your mixer to prevent a sudden loud noise from distorting the camera's mic pre's and blowing the take.

A limiter is simply a ceiling on the level of volume. It can be inserted on the signal as it enters and/or exits the mixer. It can either be "In" the signal path, making it active, or "Out," making it inactive. When a limiter is "In," its function is to stop the volume signal from exceeding a set limit, thus preventing a sudden loud signal that enters the mixer from exiting to your recorder and possibly causing distortion. I can guarantee that unexpected volume increases happen all the time when recording on location.

CHANNEL PANNING (10)

The pan select switches or rotary panning dials are used to direct the signal from each channel input to a chosen output. When you plug a microphone into a channel on

your mixer, that channel will have its own pan switch or rotary panning knob so you can assign or route the signal to either the left XLR output, right XLR output, or if panned to the center, both XLR outputs.

XLR CHANNEL INPUTS (11)

There is only one way to get sound into your mixer and that is through the XLR channel inputs. Depending on the model of your mixer, it may have two, three, four, or even six inputs.

MICROPHONE POWER (12)

You will need to supply power to most of the microphones used for location audio. Your mixer will have three choices: 48V phantom, 12T power, and dynamic.

Set the mic power to "48V phantom" (48V PH) when using most shotgun microphones and hard-wired lavaliers on the market today: 48V phantom is the industry standard for powering microphones.

- Set the mic power to "Dynamic" when using dynamic handheld microphones or when you are taking a feed from another mixer. I don't use the dynamic setting; I leave all channels set to 48V phantom all the time. *"What?! You're going to damage the mic! I've been told leaving phantom power on with a dynamic mic degrades the sound and can possibly damage the mic."* Sorry, I've never damaged a mic in 20 years of using dynamic mics, and I can't hear any difference. Your choice.

- Set the mic power to "12T" when using 12T or A/B type condenser microphones. Older Sennheiser shotgun microphones use this type of power.

TIP! If your shotgun microphone uses batteries, remove them—the 48V PH from the mixer will power it. One less thing to possibly screw up.

INPUT SELECT—MIC/LINE CHANNEL SWITCH (13)

This switch selects the input level "Mic/Line" for each input connector. Line level is about 50dB louder then mic level, so this setting must be correct for you to be able to record usable audio.

- Set your input select to "Mic" when using shotgun mics, handheld mics, hard-wired lavaliers, and wireless systems.

LOCATION AUDIO FIELD MIXER

- Set your input select to "Line" when receiving a signal from CD players or another mixer (DJ's mixer, live music mixer, etc.).

TIP! If the sound source looks like a microphone, set the input mode to "Mic."

MONITOR/HEADPHONE VOLUME (14)

Most mixers will have a rotary knob that is labeled "Monitor," "Headphones," or "Phones." This is the volume control for your headphones. *Monitor* is the term used for listening, so the monitor volume is your listening volume. This dial turns your headphone volume up and down.

MONITOR RETURN (15)

The monitor return function on a mixer is used to listen to the sound returning from a recorder or camera. After the sound signal has left your mixer and is heading down the cable to be recorded you have no idea if it actually got there! The monitor return function on a mixer solves this by receiving the signal back from the camera so you can listen to it. The function will be a two-position switch with choices like "Mix/Tape," "Direct/Return," "A/B."

MONITOR SELECT—HEADPHONE SELECT (16)

The monitor or headphone select can be a rotary dial or a combination of switches that enables you to choose what you want to listen to in your headphones. You can listen to signals that are assigned to the left or right. You can listen in mono or stereo, and sometimes the monitor select includes the monitor return function. It is used to help the operator focus on a single channel's signal without turning the other channels off.

SLATE MIC (17)

Most field mixers will have a slate mic function. This is a small microphone that is built into the mixer along with an "On/Off" button, and its function is to identify or ID takes. The mic is active only when the slate mic button is depressed.

TONE OSCILLATOR (18)

The tone oscillator is used to calibrate your mixer to a recorder or camera. This switch is a must for calibrating a video camera.

Watch Class 4—"Field Mixer Basics."

LOCATION AUDIO FIELD MIXER

Initial Setup Procedure for a Field Mixer

The first step in assuring quality recordings is to preset your mixer properly before every shoot. By setting all the switches in a configuration that assures correct input, routing, and monitoring, you'll never be wondering what's going on.

The Field Mixer Initial Setup is the foundation for all operating procedures that I use to gather high-quality recordings—there's nothing worse than turning on a piece of gear and there's problems. Mild concern can escalate into a full-blown panic attack.

The Field Mixer Initial Setup procedure will also "red flag" real equipment issues. If the system check doesn't work properly after you've completed the setup procedure, operator error will be ruled out. Your full attention can focus on troubleshooting cables, mics, headphones, or the worst case scenario, a mixer problem.

Figure 3.12

If you own your mixer it's a good idea to run this setup every couple of shoots to ensure everything is working correctly. If you rent equipment, then this procedure is a must, and you'll be thanking me for the ease of setting up the different mixers out there.

Initial Setup Procedure: The setup described below is for a four-channel field mixer. If you are using a two- or three-channel mixer set up as follows:

- Two-Channel Field Mixer: Follow the setup procedure for the four-channel mixer but use only the settings for Channels 1 and 3.
- Three-Channel Field Mixer: Follow the setup procedure for the four-channel mixer but use the settings for Channels 1, 3, and 4.

Field Mixer Initial Setup: Four-Channel Field Mixer

1. Set the mic power switch for CH1 through CH4 to "48V Phantom" (some mixers will use a single switch).
2. Set the mic select switch for CH1 and CH2 to "PH" or "Phantom" and CH3 and CH4 to "DYN" or "Dynamic" (some mixers will have this option).

LOCATION AUDIO FIELD MIXER

3. Set the input select switch for CH1 through CH4 to "Mic."
4. Set the pre-amp attenuation or PAD switch for CH1 through CH4 to "0dB." If your mixer uses a channel gain control, set CH1 through CH4 to "Unity." This will be 50 to 60 percent on the dial.
5. Set the limiter switch to "In" or "On."
6. Set CH1 channel pan switch to "Center," CH2 to "Left," and CH3 and CH4 to "Right." If you are using a mixer with rotary channel panning, make sure you are panned hard left or right (dial is completely left or right).
7. Set the master gain to "0" at détente. This will be the mixer's unity output level. THIS IS NOT OFF!
8. Adjust the channel fader for CH1 through CH4 completely to the left or "Off."
9. Adjust the high-pass filter switch or dial for CH1 and CH2 to "100Hz" and for CH3 and CH4 to "140Hz."
10. Set the monitor select switch to "Stereo."
11. Set the monitor return switch to "Mix/Direct/Off." Make sure your mixer is not set to listen to the return from a camera. Note: Mixers with a rotary monitor select may not have a separate monitor return switch.
12. Adjust the monitor volume to about "30 percent."
13. If your mixer has any linking, ganging, or MS functions, disable them. They are advanced functions that can cause confusion during the system check. This is location audio simplified not location audio extreme!

SYSTEM CHECK: FOUR-CHANNEL FIELD MIXER

After completing the Field Mixer Initial Setup, check your mixer for correct operation with the following system check.

1. Turn mixer power switch to "Int" (internal power source).
2. Press battery check and make sure you have full power.
3. Plug a set of headphones into the stereo headphone connector.
4. Engage the tone oscillator. Make sure that tone is indicating on both meters. You want both meters displaying the same reading. This assures that the meters are working properly.
5. Slowly put headphones on and adjust the monitor volume to a comfortable listening level.
6. Make sure tone is present in both left and right ear-cups. This assures that the monitoring section of the mixer is operating correctly and that both the right and left ear-cups of your headphones are working.

LOCATION AUDIO FIELD MIXER

7. Disengage the tone oscillator.
8. Plug an XLR cable and shotgun mic into XLR channel "Input 1."
9. Adjust channel fader 1 to "12 o'clock" or "50 percent."
10. Speak into the mic and make sure that audio is present on both meters and in both ear-cups of your headphones.
11. Connect a control cable into the multi-pin video connector or two XLR cables into the "Left" and "Right" XLR outputs.
12. Wiggle all cables and connections to the mixer and mic to ensure solid connections. If there are any noisy connections or cables, replace immediately.
13. You are ready to connect and calibrate the mixer to a camera.

The Field Mixer Initial Setup I've outlined gets most of the field mixers on the market today ready to go. Some of the mixers use different names for the various functions, but with the brief description of features in the "Mixer Features" section, you should be able to figure them out easily.

I have used Cooper, Sonosax, PSC, Wendt, Filmtec, SQN, Audio Developments, Sound Devices, and Shure location audio field mixers. This setup works on them all.

Over the years, I've had the opportunity to use and experiment with a wide variety of shotgun and lavalier microphones. The settings I have outlined in the Field Mixer Initial Setup best suit the ones most commonly used. You'll find that by just plugging in your mic and operating your mixer properly, most of the time you'll end up right back at the Field Mixer Initial Setup original settings. That doesn't mean these settings work for every location. You should always follow the dialing-in and operating procedures in Chapter 4 to obtain optimal location sound recordings.

Watch Class 5—"Field Mixer Initial Setup and System Check."

Recording a Safety Track

A safety track is a duplicate track that is recorded at a lower level to give extra headroom in the case of a sudden very loud sound. Since I like to record as close to "0" on the cameras meters as possible, a second recording at a lesser volume will cover my butt if an unforeseeable loud sound occurs. This setup works when you are using only a single shotgun or lavalier mic.

LOCATION AUDIO FIELD MIXER

Figure 3.13 Camera initial calibration at −20 dB

Figure 3.14 Camera safety track calibration on CH2 at −28dB

If I'm recording talent who are very ballistic with their dialogue, or we're in a loud location like a factory where sudden volume surges can happen, I will send the signal from my shotgun mic or lavalier to both CH1 and CH2 on the camera. I will adjust the camera's CH2 input level 8dB lower than the original level I set when calibrating the

camera. This second track at a lower level is a duplicate of CH1 but with an extra 8dB of headroom.

Use the oscillator tone on your mixer to calibrate.

Putting It All Together

Now that the field mixer is ready to go, it's time to attach the cables, headphones, wireless receivers, and shotgun microphones to the mixer and mixer bag and get the whole unit strapped to your body. I sometimes wear my rig for two to three hours before taking it off, so take what may seem to be silly procedures as necessary comfort adjustments that could save your back. This is what works for me. Don't hesitate to make changes to these suggestions if it makes wearing a mixer more comfortable for you.

COMFORT AND CONTROL—SHOULDER STRAPS AND HARNESSES

Comfort is a must. When you purchase a mixer bag it comes with a single padded shoulder strap for carrying—I wouldn't use it for operating. Aftermarket harnesses that go over both shoulders and crisscross in the back are fantastic for distributing the weight of the mixer and all-round comfort. They're a must if location sound is going to be your chosen career. They will not only save your back, they will also prevent the mixer from sliding to your side—which commonly occurs if you try and use the single padded carrying strap.

Figure 3.15 Single shoulder strap

Figure 3.16 Harness

LOCATION AUDIO FIELD MIXER

The first thing you want to do is set the shoulder straps on your harness so that the bottom of the mixer is just above your belt line. Any lower, and the first time you have to run, the mixer is going to bounce up and hit you right in the junk. It's not a pleasant experience!

CABLING

If you've done any location audio you're well aware of how frustrating it can be to coil and uncoil cables. Nothing says "amateur" faster than a mess of tangled and knotted cables spilling out of you.

First you must, yes must, know how to wrap a cable properly. Don't say, "Oh yeah, I know how to coil a cable." You're probably the one who doesn't! It's time to drag your sorry self off the couch and master this skill.

Wrapping a cable in the field is much harder than wrapping a typical home extension cord. What makes it so difficult is that both ends of the cables you'll be wrapping are usually connected—the mixer to the camera, and the microphone to the mixer. This means any small twist created while wrapping can turn into a tangled mess.

During a shooting day I'll coil and uncoil my cables 50 to 100 times—each!

The coiling procedure I use is a combination of two loops that you alternate. You want all cables that are hanging from your mixer to have no more than a six-inch diameter loop. Any larger and you'll be getting snagged on all kinds of stuff.

Here's how to do it, step by step.

1. Lay out a 25-foot XLR cable on the ground and straighten it out. It makes learning this skill much easier if you're not starting with a twisted up cable.
2. Put one end of the XLR in your left pocket as it would be if it was attached to the mixer. Grab the cable about 6 inches from the end with your left hand. If you're left-handed, mirror the steps. See Figure 3.17.

Figure 3.17

3. Slide your right hand about 1 foot down the cable. See Figure 3.18.

Figure 3.18

4. Bring the cable up towards you and lay the first loop into your left hand. Do not twist or curl the cable. That's the first loop. See Figure 3.19.

Figure 3.19

5. Slide your hand down the cable 1 foot again and grab it with all five fingers. See Figure 3.20.

Figure 3.20

LOCATION AUDIO FIELD MIXER

6. This time, as you bring the cable up, turn your palm away from your body, keeping the cable touching all five fingers. The cable will wrap around your right hand and all the pressure from the hanging end of the cable should be on your pinkie finger. See Figure 3.21.

Figure 3.21

7. Place the loop on the index finger of your left hand. The trick is to touch the back of your right-hand pinkie to the top or pad of your left index finger as you lay the loop in your left hand. See Figure 3.22.

Figure 3.22

41

LOCATION AUDIO FIELD MIXER

8. That's the second loop. Now alternate between the two loops and you'll be able to wrap a cable that is attached at both ends. See Figure 3.23.

Figure 3.23

Cables that are improperly wrapped for long periods of time will develop a "memory" and can be extremely difficult to straighten out. Often rental houses end up with cables like this, so look for the telltale sign of twisted and bent loops. Sometimes they're beyond repair, and you'll fight them every wrap.

> Master how to wrap a cable properly before you go public. It should take no more than 15 seconds to wrap a 25-foot XLR cable with loops that are even and twist-free.

If you purchase new cables, make sure you wrap and store them properly by hanging them or laying them flat. If you throw them in a box all kinked up, that's what they're going to look like when you take them out.

A cable that's been improperly wrapped over and over will eventually break the smaller wires inside, and it can't be repaired. The very expensive control cable can have as many as ten smaller wires inside, making it even more fragile—a costly mistake if it's damaged.

VELCRO CABLE TIES

To attach the cables to your mixer you'll need to purchase a set of Velcro cable ties with clips. They're a bit of a specialty item, so they're not cheap, but you'll be glad you have them. Your favorite retailer of all things location audio should stock them.

Clip one Velcro tie on the right side and one on the left where the shoulder harness attaches to the top of the mixer bag. See Figure 3.24.

Figure 3.24

Figure 3.25

TIP! When letting out the full length of boom or control cable, always leave at least one loop in the Velcro tie. This extra loop acts as a strain relief that will protect the connectors on the cable and mixer.

BALANCING YOUR MIXER

Keeping your mixer in the center of your body and preventing cable tangles will be a major problem when you first start out. Harness, Velcro ties, and properly wrapped cables will help, but it's important you balance the weight that's hanging around your neck. You can do this by separating the boom cable from the control cable and tying them to opposite sides of the mixer bag with Velcro ties.

Since not all mixers have the inputs and outputs on the side you want, you may have to feed cables through the mixer bag to achieve balance.

If you boom primarily with your right hand on the butt end of the boom pole, attach the XLR for the shotgun mic to the Velcro tie on the right side of the mixer bag. See Figure 3.25. Attach the control cable, snake, or pair of XLR cables that are going to the camera to the Velcro tie on the left side of the mixer bag.

If you boom primarily with your left hand on the butt end of the boom pole, reverse the above procedure.

It doesn't matter which side the connections are on, just make sure the cables exit the mixer bag and are secured on the proper side. This will prevent tangles and help balance the mixer.

HEADPHONES

We all know how to plug in a set of headphones and put them on. No rocket science here. The problems that arise with headphones in location audio are the long length of cable or curly-type cord that come with them.

The length of cable will be needed, but it is a bit of a pain if it's left hanging out when booming or moving about. A simple remedy is to stuff the excess cable down the inside of the front of the mixer bag—leave only enough length to put them on. The excess headphone cable will sit inside the mixer bag and stay contained.

At times throughout the day you will need the full length of headphone cable, but I find that wrapping or fastening the excess cable to the outside of the mixer bag is just another cable to get tangled with—not to mention it looks kind of messy.

Figure 3.26 Sony 7506 and Sennheiser HD25 location audio headphones

It's also good practice to have the headphone cable exit the top of the mixer bag on the same side that the cable attaches to your headphones. If the cable attaches to the left ear-cup of your headphones, make the cable exit the top left-hand side of the mixer bag. This will keep the small amount of exposed cable out of your way.

LOCATION AUDIO FIELD MIXER

TIP! If your mixer bag doesn't have a Velcro loop for storing your headphones between shots, a karabiner works great. Clip it to the front of your mixer bag—it makes it easy to store and access your headphones. Make sure to get one big enough so that it doesn't damage the headband padding on your headphones.

Figure 3.27

Figure 3.28

Figure 3.29 Nicely balanced field mixer

PICTURE PERFECT

Putting it all together will make a huge difference in not only how you operate but your overall professional appearance. The mixer will be balanced with neatly coiled cables on both sides of the mixer. You won't get the two tangled, and the boom cable won't be hanging in your face when booming.

Watch Class 6—"Putting Your Gear Together."

LOCATION AUDIO FIELD MIXER

Tying into the Camera

Now that the cables are attached and secured to the mixer and mixer bag, you're ready to tie into the camera. Cabling your mixer to the camera is simple, but you do have three options for what type of cable you use.

All mixers will have two XLR outputs (left and right) for sending the sound via two XLR cables to the camera. Some mixers, in addition to the two XLR outputs, will have a monitor return jack that provides a return from the camera when used with a snake cable.

Figure 3.30 XLR cable

A snake is a single cable that has a pair of XLRs at each end as well as a 1/8-inch stereo connector to return the signal from the camera for monitoring. The third option is a multi-pin video connector for attaching a control cable.

Figure 3.31 Snake cable

LOCATION AUDIO FIELD MIXER

Figure 3.32 Control cable

PAIR OF XLR CABLES

For attaching the two XLR outputs to a camera, simply plug the "Left" output of the mixer into the left input (or Input 1) on the camera, and the "Right" output of the mixer into the right input (or Input 2) on the camera using a pair of XLR cables. You can purchase a single cable that has two XLRs in it or tie two separate XLRs together. It's also a good idea to label the cable ends so you know which is left and which is right.

Figure 3.33 A pair of XLR cables are connected into the mixer's outputs.

If you're going to be tying two XLRs together don't use plastic cable ties (zap-straps). They'll cut your hands up by the end of the day. Use electrical tape. I know it leaves gum on the cable when taken apart (although this is easy to clean with rubbing alcohol), but it's flexible for easy coiling, and it's black so it looks clean on a black XLR cable.

SNAKE CAABLE

If you are using a snake (see Figure 3.31), plug the "Left" output of the mixer into the left input (or Input 1) on the camera, and the "Right" output of the mixer into the right

LOCATION AUDIO FIELD MIXER

input (or Input 2) on the camera. Plug the 1/8-inch stereo connector into the monitor return input on the mixer, and the headphone jack on the camera. The snake allows the sound to exit the mixer through a single cable that not only sends the sound to the camera but will return the sound for you to monitor.

Figure 3.34 Snake cable with 1/8-inch mini connecting into mixer

CONTROL CABLE

As mentioned earlier, you may want to use the multi-pin video connector with a control cable (see Figure 3.32) to tie into the camera. If your mixer has this connector, you want to seriously consider purchasing a control cable. The multi-pin video connector with a control cable works the same as the snake for connecting and monitor return, with the added bonus of freeing up the XLR outputs to send signal to a second camera if needed. One camera would have the control cable plugged into it, and the second camera would have two XLRs coming from the main XLR outputs plugged into it. This option is a must for a two-camera interview.

Figure 3.35 Control cable connected to mixer's camera output

LOCATION AUDIO FIELD MIXER

Like most things, snakes and control cables are a little pricey, but the peace of mind of knowing your sound is getting to the camera with the monitor return is well worth it. These cables usually come in 15- and 25-foot lengths. I find the 25-foot length a little bulky for shoots where I need to be mobile with the camera operator, but I do carry one for when the camera op wants to be further away from talent and I need more cable.

Watch Class 7—"Tying into a Video Camera."

Connecting a Shotgun Mic

For the shotgun microphone cable, it's best to get a length of cable that is 4 feet to 5 feet longer than your boom pole. You don't want a 25-foot XLR if you are using a 9-foot boom pole. It's just too much cable, and it will add unnecessary weight to your mixer. I use an 11-foot boom pole and have a 15-foot XLR cable. That's a perfect length when the boom is fully extended.

As mentioned earlier, you may have to run the XLR cable for the boom through the mixer bag, so make sure you don't make the boom cable too short when cutting it to length.

Make sure the XLR snaps in tightly to the shotgun mic and mixer when connecting.

TIP! If you are using a pigtail (a short cloth-covered XLR cable that is attached to the pistol grip of a Rycote system), make sure the release for the XLR connector on the pigtail of the pistol grip is facing outward. If it's buried in the handle of the pistol grip, the XLR cable from your mixer can become detached, possibly blowing a take. See Figure 3.36.

Figure 3.36

Connecting a Wireless System

For attaching wireless receivers to your mixer, your mixer bag will have a compartment designed to secure the receivers so they don't fall out. See Figure 3.37. For cable length, you don't want extra cable adding weight and clutter to your setup: make, or buy, a short length of cable that runs perfectly from the mixer bag wireless receiver

LOCATION AUDIO FIELD MIXER

compartment to the channel input on the mixer. See Figure 3.38. If you're going to use wireless systems, I recommend you prewire them into your mixer and test them before you head off to the gig.

Figure 3.37

Figure 3.38 Supplied cable for wireless—nice and short!

Professional Impression

How you look when you are all put together is important. Operators that look like they've just stepped out of a bar after a few too many do themselves a disservice. A well-put-together mixer will help in smooth, error-free operation, and you'll look like you

LOCATION AUDIO FIELD MIXER

know what you're doing. Tangled cables hanging all over the place and headphones choking you like a neck brace will not bring the client back. Take a look in the mirror: Would you hire this person? Does your appearance instill confidence in the client that you are a professional location audio operator?

Figure 3.39

CHAPTER 4

Field Mixer Operating Techniques

My Guarantee to You!
Operating and Monitoring Techniques
Task #1 — Assigning/Panning
Task #2 — Dialing In
Task #3 — Monitoring Function
Task #4 — Listening
Task #5 — Shooting
Room Tone Is a Must!

My Guarantee to You!

Learning to operate a field location audio mixer can be intimidating. The reality, however, is that it's quite simple. In fact, it's so simple that I guarantee if you follow some straightforward procedures, your screw-ups will be few and far between.

Operating and Monitoring Techniques

I've touched on a few operating and monitoring tips when explaining the features, functions, and setup of the mixer, but now it's time to get specific. It's time to focus on the mixer controls that effect the sound of your recording, as well as on learning how

to listen and monitor properly. Understanding how and what you are listening for is as important, if not more important, than knowing which dials to adjust.

When you're ready to record in the field, the anticipation and sometimes craziness of production, coupled with keeping the day moving forward, can make finer adjustments difficult to focus on.

I've broken down these convoluted, often confusing, procedures into four smaller tasks, and given them specific times to implement. This makes it easier to focus on the minute details you need to be familiar with.

Focus! The next few sections are long and loaded with many "absolute musts" for achieving quality recordings. This will be time well spent.

Task #1 Assigning/Panning—Choose which output each channel's signal will exit the mixer.

Task #2 Dialing In—A step-by-step procedure that will ready the mixer for recording.

Task #3 Monitoring Function—How to set up, calibrate, and operate the monitor.

Task #4 Listening—How to effectively focus your listening.

Task #5 Shooting—Making adjustments to the mixer during recording.

Task #1—Assigning/Panning

Choosing which channel's signal will exit the mixer.

Assigning or panning on a field mixer is when you determine which output (left or right) the sound from each input (Channels 1–4) are going to be assigned. This decision will determine which track on your recorder or camera (CH1, CH2, or both) the sound will be recorded on.

The assigning or panning of an audio signal on a field mixer is quite straightforward. However, due to the placement and size of these switches on many mixers, it's easy to accidentally bump or incorrectly set them.

Sometimes during hectic and rushed setup times, panning can get mixed up—a mistake that cannot be repaired. In the blistering cold with numb fingers, or in pitch-black darkness, a screw-up can be hard to avoid if a microphone is added due to an unexpected change to the shot. Add in the pressure of *"we have to shoot right now"* and mistakes will happen.

FIELD MIXER OPERATING TECHNIQUES

HOW THE PAN FUNCTION WORKS

Figure 4.1 Pan dial left

Figure 4.2 Pan dial center

FIELD MIXER OPERATING TECHNIQUES

Figure 4.3 Pan dial right

When you set or dial the pan function to L ("Left"), R ("Right"), or L/R (both "Left" and "Right"), you are assigning the sound to exit the mixer via that designated output.

- If you connect a microphone to Input 1 on your mixer and set Channel 1 Pan to L, the sound will only exit the "Left" output on the mixer and record on the "Left" or Channel 1 on the recorder or camera you have connected to.

- If you chose L/R, or "Center," with the Channel 1 Pan dial or switch, the sound would come out of both the left and right outputs.

- If you chose R with the Channel 1 Pan, the sound from the microphone that is plugged into Input 1 on your mixer would be panned or assigned to the "Right" output.

- For mixers with a rotary pan dial, turn it completely left to send the sound out of the "Left" output, or completely right to send the signal out of the "Right" output. Set the dial to the middle to send the signal out of both the "Left" and "Right" outputs.

Easy Panning Solution

Here's how to preset a mixer and prewire all your mics and wireless systems so you are ready to tackle any situation efficiently and accurately—and minimize the risk

FIELD MIXER OPERATING TECHNIQUES

of panning errors. This example uses the Field Mixer Initial Setup procedure for a four-channel field mixer.

Figure 4.4

When I arrive at a location, my mixer is ready to go with a nicely coiled XLR cable, Velcro tied to my mixer bag for a shotgun microphone plugged into Input 1, and a pair of wireless systems plugged into Inputs 3 and 4. See Figure 4.4.

Figure 4.5

56

FIELD MIXER OPERATING TECHNIQUES

If a shot requires only a single shotgun microphone, all I need to do is connect a shotgun to the XLR cable and I'm ready to go. CH1 panning is preset to the Center position and will send the signal out both left and right outputs to be recorded on both channels of the camera. See Figure 4.5.

Numerous times over the years I've been asked to try and fix recordings with panning errors. They all ended up in the trash.

If I need to add a wireless lavalier for a shot, I simply unplug the shotgun microphone from XLR Input 1 and plug it into XLR Input 2. The wireless is prewired into XLR Input 3. The mixer is preset to pan XLR Input 2 (now my shotgun mic) to the left output and XLR Input 3 (the wireless) to the right output. No chance for error! See Figure 4.6.

Figure 4.6

If the next shot required only a shotgun microphone, which in video is a majority of the time, I would simply move the XLR for the shotgun microphone from XLR Input 2 back to XLR Input 1.

Say for the next shot I need two wireless mics and the shotgun. I'd simply plug the shotgun microphone back into XLR Input 2 (it's panned left). The wireless systems are prewired into XLR Inputs 3 and 4 (panned right).

As you can see, by presetting the mixer and prewiring all mics and wireless systems, you're efficient and accurate, and the chance for an assigning error is minimized.

Now here's some good news—you can pan two or three lavalier microphones together if you so choose without any problems. So, a four-channel mixer can have one

57

shotgun panned to the left output and up to three lavaliers panned to the right with no issues.

I rarely change the pan settings from the Field Mixer Initial Setup discussed earlier in this chapter (and outlined in detail in Chapter 3)—when I'm using multiple lavalier microphones and no shotgun, I'll leave them plugged into XLR Inputs 3 and 4 and adjust Channel 3 Pan to the left. This will separate the two microphones by placing them on separate tracks on the camera.

"But I don't want all the dialogue coming out of the left or right speaker."

You'd be surprised at how many times I've heard this from the uninformed. The panning you choose on your field mixer does not dictate the final mix of the show.

The field mixer's pan function is used to separate and isolate the individual inputs from one another during recording. This makes it easier to monitor individual inputs and gives more flexibility when editing the sound in post—and that's where the final decision for the stereo mix will be made.

A Little Note Regarding Mono

Most location audio recording using shotgun mics will be mono. *All* lavalier microphones will be mono. Don't think that by choosing L/R or setting the panning dial to the center position you are recording in stereo—sorry, you're not. Just because you can hear the sound in both ear-cups still doesn't mean you are recording in stereo. We are mono!

So don't think that you are mixing in stereo when recording on location. This is completely wrong, so wipe it out of your thoughts. You are mono.

Task #2—Dialing In

A step-by-step procedure to ready the mixer for recording.

Dialing In is a step-by-step procedure that will ready the mixer to record. This is where you adjust the preamp attenuator (PAD), channel fader, channel gain, and high-pass filter to bring clarity and richness to your sound.

Figure 4.7 Mixing

This procedure will be the same every time you get ready to record. The final settings of the various switches may differ from location to location and talent to talent, but the procedure for choosing mixer settings will never change. So once you've got this procedure down, it's just a matter of implementing it before recording.

Be careful—you don't want to be changing your settings every time the camera operator hits record. Once you've adjusted your mixer for a scene or location, you need to stay close to those settings to keep the ambient sound consistent throughout.

THE THREE STEPS

The Field Mixer Initial Setup procedure has you 75 percent of the way to great recordings. You only need to fine-tune a few functions with three quick steps to achieve greatness:

Step One: Choose the mic and mic placement.

Step Two: Operate at unity.

Step Three: Set the high-pass filter.

STEP ONE: MIC PLACEMENT

With talent in position, you need to find the sweet spot for booming when using a shotgun microphone, or attach a lavalier that's going to send to the mixer the best sound possible for the chosen location.

Sorry for not giving all the info here, but there's a lot to it, and I'm focusing on dialing in the mixer in this section. Check out Chapter 5, "Shotgun Microphones," for lessons on how to use shotgun microphones, and Chapter 7, "Lavalier Microphones," for using lavalier mics.

Figure 4.8

FIELD MIXER OPERATING TECHNIQUES

Figure 4.9

For now, this information is not necessary for moving forward. So let's move on to Step Two.

STEP TWO: OPERATE AT UNITY

Definition of Unity

Unity is the optimal operating level of a given system.

It's vital that the sound entering the mixer, passing through the mixer, and exiting the mixer is at a level that best suits the mixer's circuitry. This is called *unity*, and we always want to dial in the mixer's settings and operate within the mixer's unity range. Operating outside this range can add hiss or hum to a recording.

Unity is achieved by adjusting channel volume, master gain, pre-amp attenuator (PAD), or channel gain (trim), and properly metering. Take your time here, and make sure you can operate your mixer at unity.

Figure 4.10

60

Adjusting the Master Gain

I start here because the master gain is a "set-and-forget" dial. It will have a "0" setting and will probably have a détente at this spot. As you might recall from Chapter 3, *détente* is a notch so you can set it exactly every time. The "0" setting is not "Off" but the unity output gain of your mixer. Set it here and leave it alone. See Figure 4.11.

Figure 4.11

The only time to adjust the master gain is when you engage the tone oscillator for calibration. Some mixers will continue to send signal from the channel inputs when the tone oscillator is engaged. So, by turning the master gain fully counterclockwise to the "off" position, any open mics will be muted, keeping tone clean for calibrating. Most mixers will mute all channel inputs when the tone oscillator is engaged.

Adjusting the Channel Fader

Each channel fader has a unity range or area that the mixer operates at its quietest. On a studio console this is indicated with a shaded area on the channel fader. We poor souls in the field have to figure it out for ourselves. The channel fader unity range is commonly found between 12 o'clock and 3 o'clock. You should operate in this area. See Figure 4.12.

FIELD MIXER OPERATING TECHNIQUES

Figure 4.12

If you operate your mixer with the channel fader below the unity range (let's say 10 o'clock), the recording will seem dull and the mixer may add bottom frequency hum. If the channel fader is set above the unity range (let's say 4 o'clock), the mixer will start adding hiss as you push the mixer beyond its unity range.

Proper Metering

The meters are your visual representation of the sound as it passes through your mixer. You need to know where they should be reading to stay within the mixer's unity range.

If your mixer has PPM meters (PPM meters have a "dB" symbol), you want to operate between −2 and +8. This is quite hot—which I'll explain later. See Figure 4.13.

FIELD MIXER OPERATING TECHNIQUES

Figure 4.13

If the mixer has VU meters (VU meters have a "VU" symbol), you want to operate between –4 and +2—again, a very hot signal.

Setting the Pre-Amp Attenuator (PAD) or Channel Gain

With all the information necessary regarding channel unity and meter unity, we can finally start making adjustments to the mixer. As defined earlier, when a sound source enters the mixer from a mic, you need to make sure that it is at a level or volume that the mixer can handle. Depending on the type of mixer you are using, it will use either a pre-amp attenuator (PAD) or channel gain (trim) to increase or decrease the level of signal *entering* the mixer's pre-amp.

Figure 4.14 Mixer with pre-amp attenuator

63

FIELD MIXER OPERATING TECHNIQUES

Figure 4.15 Mixer with channel gains (trim)

Mixers with a pre-amp attenuator (Pad) adjust as follows:

1. Plug a mic into XLR Input 1.
2. Set the master fader to "0" or Unity.
3. Set CH1 PAD to "0."
4. Ask talent to speak at performance level.
5. Starting with the CH1 fader at unity, slowly increase the volume until the needle is bouncing within the meter's unity range (between −2 and +8 on a PPM meter). If the CH1 fader ends up within the channel fader unity range (12 o'clock to 3 o'clock), you are golden. The mixer is ready to go, and you can start operating.
6. If talent starts talking and the needles are beyond the meter's unity range, you will need to adjust the PAD. Switch it from "0 dB" to "−10dB." This will decrease the amount of signal entering the mixer. If the addition of a −10dB PAD allows you to adjust CH1 fader within its unity range (between 12 o'clock and 3 o'clock), and the meters are between −2 and +8, you're operating at unity and again, you're golden. If you still can't increase CH1 fader up to the channel unity range without the needle going beyond the meter's unity range, you'll need to increase the PAD to "−20dB."

Mixers with a channel gain (trim) adjust as follows:

1. Plug a mic into XLR "Input 1."
2. Set the master fader to "0" or unity.
3. Set CH1 fader around 1 o'clock.
4. Ask talent to talk at performance level.

FIELD MIXER OPERATING TECHNIQUES

5. Start with CH1 channel gain turned all the way left, and increase it until the needle is bouncing within the meter's unity range (between −2 and +8 on a PPM meter).

Think of the channel gain as "coarse" gain adjustment. Once the coarse adjustment is made, use the channel fader for fine adjustments during recording.

STEP THREE: SET THE HIGH-PASS FILTER

The high-pass filter, also known as a low-cut filter, is a function that's often overlooked and dismissed by many field recordists. In my opinion, it's important to adjust this function properly in every location to give separation between the low frequencies of the location's ambience and the low frequencies of the talent's voice. This is not a "set-and-forget" function—and it's definitely not a function for you to dismiss.

The high-pass filter's job is to cut low frequencies. The higher you adjust in frequency the less bass or low sounds you're allowing to enter your mixer.

Your mixer will come with either a stepped or sweepable high-pass filter. They do the same thing, except one is a dial, the other a three-way switch.

To correctly adjust a high-pass filter follow this simple procedure.

Setting a Stepped High-Pass Filter

Figure 4.16 Stepped high-pass filter, 20Hz to 140Hz

Start with setting it to its lowest setting—usually 20Hz—and listen to the talent's voice. Focus your listening on the low frequencies of his or her voice and not the ambience. Switch the filter to its next higher setting (let's say 100Hz), and listen if the filter cuts into the low frequencies of the voice. As you increase the high-pass filter (20Hz

FIELD MIXER OPERATING TECHNIQUES

to 100Hz), you're cutting or not allowing the frequencies below the selected frequency to be recorded. The talent's voice will sound thinner if the high-pass is cutting into it.

> *You will find that for men, the cut will be around 80–100Hz, and for woman, around 140–150Hz. Very rarely do I set the high-pass filter to 20Hz or off.*

Switch back and forth as many times as necessary until you clearly hear where the high-pass filter is cutting. If the voice is not being touched, switch the high-pass filter to its highest setting (let's say 140Hz) and again listen for thinning in the voice. Set the high-pass filter just below the low frequencies of the talent's voice.

When the high-pass filter is set correctly, the talent's voice will seem louder and more "on top" of the ambience. This cutting of low frequencies that are not present in the talent's voice will result in less competition from the ambience, giving more separation and clarity to the voice.

> *High-pass filter: If the voice seems to fall into the ambience when you increase the high-pass filter, you have set it too high. Back it off one setting.*

Setting a Sweepable High-Pass filter

Figure 4.17 Sweepable high-pass filter, 80Hz to 240Hz

FIELD MIXER OPERATING TECHNIQUES

Even though the stepped high-pass filter works perfectly fine, I prefer a sweepable high-pass filter. You can be more accurate where you cut since the sweepable dial is in finer frequency increments.

Start with the dial completely to the left, and slowly sweep it up while listening for the filter to cut into the low frequencies of the talent's voice. Set the filter just below where you hear the lows, or bottom, of the talent's voice get weaker.

Figure 4.18 Adjusting the high-pass filter

Once again, when the high-pass filter is set correctly, the talent's voice will seem louder and more "on top" of the ambience. This cutting of low frequencies that are not present in the voice will result in less competition from the ambience, giving more separation and clarity to the voice.

Exception to this rule! When offending low frequencies of ambience are equal to or louder than the voice's low frequencies, you may find it necessary to cut into the voice. When you do this, focus your listening on the presence of the voice. If it seems to get clearer and or louder, don't hesitate to cut higher than you'd expect.

If you're having a tough time hearing the high-pass filter, here's a simple test you can do that should make it clearer.

1. Plug a mic into XLR "Input 1." Turn up the CH1 fader to 50 percent or 12 o'clock.

FIELD MIXER OPERATING TECHNIQUES

2. If the mic has a bass roll-off switch, make sure it's in the "Off" position. (see figure 4.19)

3. Switch the high-pass filter to its lowest setting, "20Hz," or if you have a sweepable rotary dial turn it completely left.

4. Turn your monitor volume up loud enough so you can clearly hear the bassy, rumbly low frequencies of the room you are in. It is best if no one is talking. Focus your listening on the bottom or lower sounds of the environment.

5. Switch the high-pass filter back and forth between the lowest and highest settings (20Hz and 140Hz), or turn the rotary dial from hard left to hard right. You should hear the bassy rumble of the ambience become less. That is your high-pass filter at work. This is where you need to focus your listening when you are making adjustments with the high-pass filter.

Figure 4.19 Step 2: The bass roll-off is off when in the "—" position.

It's important that you clearly hear the change in the bass or low frequencies when you make an adjustment to the high-pass filter. Don't just sort of hear it working. Take the time and practice. You'll quickly tune your listening to the frequencies that your high-pass filter affects, and you'll be able to use this function to its full potential.

This may sound complicated, but it's not. You'll soon be making the decision on where to set the high-pass filter in a matter of seconds.

High-Pass Filter Warning!

By ignoring the high-pass filter on your mixer, you are exposing yourself to a major disaster that low frequencies can inflict on a recording. Do not think that by leaving the high-pass filter at its lowest setting (20Hz or off) you are Okay. *Wrong!*

At its lowest setting you are allowing low frequencies to enter the mixer, possibly overloading or distorting the pre-amp. The worst case is something called "false metering." This is when low frequencies that you can't hear enter the mixer and indicate on the meters that you have the correct amount of input. You'll find you can't increase the channel volume without distortion, even though the dialogue seems weak. I've been there, and it was a frustrated flip of the high-pass filter that fixed the problem.

FIELD MIXER OPERATING TECHNIQUES

In the real world, low frequency ambience is everywhere, and the high-pass filter will help you to control it.

You've now "dialed in" your mixer and are ready to record. With these three simple steps you've set your mixer properly for the location and the talent's voice. Whether your mixer uses a pre-amp attenuator or channel gain, stepped or sweepable high-pass filters, PPM or VU meters, it's an absolute must that you control the location's low frequencies, allow only the perfect level of signal to enter your mixer's pre-amps, and operate your mixer at unity.

ROLL OUT THE CRITICS

As I stated earlier, the level I suggest recording at is very hot! The way I record in the field is "hard to" the mixers limiter—meaning I keep the level of signal either activating the limiter (above the limiter's threshold) or just barely below it.

Figure 4.20

I've received more than one email questioning this style of recording, but it works! I was as surprised as the next guy when I stumbled upon the benefits of heavy limiting. Your manual will indicate the threshold of the limiter, and I recommend you operate at and slightly above this number. On some mixers you can set the threshold level. I recommend +2 for PPM meters, and 0 for VU meters. The metering range that I recommend will assure that you're operating hard to the limiters. This operating style is definitely not standard procedure and does get questioned, but the benefits of recording this way are many.

Some argue that the ambience bed is increased, or you can hear a pumping effect when the limiter kicks in and out.

Sure the ambience gets louder, but I make sure that my location has been properly prepped and all criteria for good separation are being met. Your recordings are going to be heavily compressed for broadcast, so I prefer to know what my recordings are really going to sound like—no sticking your head in the sand! Regarding the limiter pumping, it's active the majority of the time, so pumping is not an issue. Also, the limiters on most location audio mixers are more like compressors, and the clamp-down effect of a real brick-wall limiter does not occur. Most new mixers have limiters that are of excellent quality. You'll be hard-pressed to hear them when operating the way I recommend.

Figure 4.21 A good level going to the camera

Benefits of Recording Hard to the Limiter

1. With digital recorders and cameras, you can never exceed 0dB. The limiter coupled with proper calibration will prevent this from ever happening.

2. By recording hard on the limiter you minimize the amount of gain between the quietest and loudest signals. This gives you a tight recording that translates well for broadcast. The broadcasters are going to squash the hell out of your recording anyway, so you might as well tighten it up as much as you can in the field. By tightening the recording in the field, you're not going to be surprised with an ambience bed that is suddenly too loud after the post audio engineer has increased the volume of your recording and compressed it for broadcast.

3. You'll have a better signal-to-noise ratio. Many of the prosumer cameras on the market today are quite noisy, so you want to be as close to "0" on the camera's meters as possible to increase the signal-to-noise ratio. With proper calibration, the limiters will guarantee you achieve this without exposing yourself to distortion.

There are more benefits I could list, but I think you get the idea. If you're still not convinced, try it out for yourself. You'll be pleasantly surprised. I've got a long list of satisfied clients that are more than happy with the final product this operating procedure produces.

FIELD MIXER OPERATING TECHNIQUES

ENJOY THE RIDE!

As you gain experience with your location audio mixer you can try new things, but to be honest there are many settings on your mixer that will rarely get changed from the Field Mixer Initial Setup. These precise instructions for setup, dialing in, and operating will have you well on your way to excellent tracks. Keep it simple, and location recording will become a walk in the park.

Watch Class 8—"Roll Out the Critics."

Task #3—Monitoring Function

How to set up, calibrate, and operate the monitor section.

Knowing how to operate your mixer to monitor the individual signals as they pass through your mixer is very important. Being able to separate and isolate incoming signals from each other makes it easier to hear what is going on when you're recording with multiple mics.

Figure 4.22 Monitor section on a field mixer

Your mixer has the ability to send your headphones a signal from a single channel's input and signals assigned to an individual output, to allow you to listen in

71

stereo or mono, and even to return the sound back from a camera or recorder for you to monitor.

There are many configurations for the monitoring function on the various field mixers. Some will have a single rotary monitor select with a PFL (pre/post-fade listen) to toggle through the various monitoring options, while others use a combination of monitor select and headphone select functions, but the resulting listening choices are the same. In this section we'll be focusing on the monitor and headphone select switch or dial, monitor volume, monitor return, and the PFL functions on your mixer.

MONITORING BASICS

The monitor section of your mixer works in conjunction with the individual channel panning functions. Basically, any channel panned to the left will be heard in your left ear-cup. Any channel panned to the right will be heard in your right ear-cup. Channels panned to the center are heard in both ear-cups. Mixers that do not have a monitor select function (some two- and three-channel mixers) work this way.

Monitor Select

The monitor select function can vary greatly from mixer to mixer. It will be used in conjunction with PFLs or a separate headphone select function for mixers without PFLs. Here's where you choose how you will listen and isolate the signals to monitor effectively.

Headphone Select

Many older and some smaller mixers without PFLs will use a separate headphone select switch to listen in mono or stereo.

The PFL (Pre/Post-Fade Listen)

The PFL function on a field mixer makes it easy to monitor individual channels with a single switch. Each channel has a dedicated PFL. When engaged, the signal to the selected channel is isolated and sent to your headphones.

The more expensive four-, five-, and six-channel field mixers come equipped with PFLs. This function is a must if you're working in reality TV or any shoot that requires numerous lavaliers.

FIELD MIXER OPERATING TECHNIQUES

Monitor Volume

The monitor volume increases or decreases the sound to your headphones—we're all familiar with an iPod, but in location sound I find it's a control that gets overlooked. It shouldn't. It needs to be adjusted properly.

You want the volume in your headphones to be just slightly louder than the ambience of the location. If you're in a loud location, you'll need to increase the volume to your headphones so you are hearing the sound coming from your mixer and not sound that could be leaking in the sides of the headphones' ear-cups.

Figure 4.23 Monitor volume, also called headphone volume

If the location is quiet, turn them down to prevent the sound from bleeding out of the ear-cups. I had an embarrassing moment when my headphones were so loud that my shotgun mic was picking up the sound bleed. I was hearing an echo and I couldn't figure out what was going on. It was the talent who told me my headphones were so loud she could hear them. She was six feet away!

TIP! If you know you are going into a loud location, put your headphones on before entering. Increase the monitor volume slowly over three to five minutes. This allows your ears time to acclimatize. This could prevent injury to your ears.

FIELD MIXER OPERATING TECHNIQUES

Make sure you use headphones designed for location audio. Your headphones should be closed (the ear-cups do not have ventilation ports) and make a good seal around your ears. This will allow you to listen at a lower volume, preventing listening fatigue and sound bleed.

Monitor Return

The monitor return function on a mixer is used to listen to the returning signal you have sent to a recorder or camera. After the sound signal has left your mixer and is off to be recorded, you have no idea if it actually got there! The monitor return function on a mixer solves this by receiving the signal back from the camera so you can listen to it. This function can be part of the monitor select dial or a separate switch. It has various names, like "Mix/Tape," "Direct/Return," or "A/Off/B."

Figure 4.24

It's vital you check your monitor return often! During a take, I'll switch back and forth numerous times between listening to the mixer and listening to the monitor return to ensure that sound is being recorded on the camera.

The monitor return function is enabled only when using a snake or control cable. If you're using two XLR cables or a wireless hop to tie into the camera, this function does not work. (I'll cover a "wireless hop" in Chapter 8.)

FIELD MIXER OPERATING TECHNIQUES

Figure 4.25

CALIBRATING THE MONITOR RETURN

1. Attach the two XLRs from the snake or control cable into the camera's input jacks, and the 1/8-inch mini headphone connector into the camera's headphone jack.

Figure 4.26 Step 1

FIELD MIXER OPERATING TECHNIQUES

2. Turn the camera's monitor volume all the way up.
3. If the camera has an alarm function, turn it off.

Figure 4.27 Steps 2 and 3

4. Engage the tone oscillator on the mixer.

Figure 4.28 Step 4

FIELD MIXER OPERATING TECHNIQUES

5. Switch the mixer's monitor return function so it is receiving the tone back from the camera.
6. Put your headphones on.
7. If the camera has a monitor select, set it to "Stereo," "1 and 2," or "L/R"—anything that will send both audio tracks back to your mixer. With your headphones plugged into your mixer and the tone oscillator engaged, toggle the monitor return function back and forth so you hear tone from the mixer and then the tone returning from the camera.
8. If the tone sounds the same when listening to the mixer and the return, you are calibrated. If the tone returning from the camera is louder, decrease the camera's monitor volume. If it's a lot quieter, there should be an adjustment you can make to the mixer's monitor return volume (this is usually a small jeweler's screwdriver–type adjustment). Don't be surprised if the monitor return is a little quieter than the mixer's headphone volume. Even with everything maxed out, it's very common.
9. Don't Panic! If you're not cabled into the camera or the camera is turned off, the monitor return will have no sound. You may see the meters bouncing around but can't hear anything. Before you think your headphones have died, check the monitor return switch.

EXAMPLE OF HOW THE MONITOR FUNCTION WORKS

Our first example is using a mixer with the monitor select and headphone select functions.

Let's say you've plugged a shotgun mic into XLR Input 2 on your mixer and it's panned left, and you've plugged a lavalier into XLR Input 3 and it's panned right. The monitor return is set to monitor the mixer, the headphone select is set to "Stereo," and the monitor select on the mixer is set to "Center"—you would hear the shotgun mic in your left ear-cup and the lavalier in the right ear-cup.

If you switched the monitor select on the mixer to "Left," you'd hear the shotgun mic in the left ear-cup and the lavalier would be muted (off) in the right. The lavalier would still be sent to the camera and recorded, but you wouldn't hear it. This allows you to focus your listening on the shotgun mic without being distracted by the lavalier.

Figure 4.29

If you switched the monitor select on the mixer to "Right," you'd hear the lavalier in the right ear-cup and the shotgun mic would be muted (off) in the left. You'd only hear the lavalier mic in your right ear-cup.

77

Monitoring in stereo assures that the panning is correct because of the separation in your headphones.

Now some operators like to hear the sound in both ear-cups all the time. To monitor this way, you'd have to switch the headphone select to "Mono." This will send both mics into both ear-cups.

When the monitor select is set to "Center" you would hear both mics in both ear-cups (mono). There would be no separation of the two sound signals in your headphones. If you switched the monitor select to the "Left," you would hear the shotgun mic in both left and right ear-cups. The lavalier would be muted (off) only in your headphones. The lavalier would still be going to the camera, but you wouldn't hear it. The advantage to listening in mono is the sound will be present in both left and right ear-cups, making it easier to focus on.

How you choose to monitor while recording is up to you. Try monitoring in mono and stereo and work at becoming proficient at isolating channels.

This example uses a mixer with a monitor select and PFLs.

Using the same setup as the previous example: shotgun mic into XLR Input 2 panned left, and lavalier into XLR Input 3 panned right, with the monitor return set to monitor the mixer.

The monitor select works the same as the above example. But now you can toggle between listening in mono or stereo, or isolate all mics panned to the "Left" output, or all mics panned to the "Right" output.

To isolate the individual channels you'll use the PFL function. Remember that the monitor select does not effect the PFL in any way.

If I wanted to isolate and listen to the shotgun, I'd toggle the Channel 2 PFL and the shotgun would be in both ear-cups (mono) and all other channels would be muted to my headphones. If I wanted to isolate the lavalier, I'd toggle the PFL for Channel 3.

On most mixers you can engage multiple PFLs to listen to several channels simultaneously.

Task #4—Listening

How to effectively focus your listening.

Knowing how to monitor or listen is just as important as learning how to operate your mixer. In my opinion, an operator's ability to "listen critically" far outweighs all other aspects of field recording. If you can't hear past the dialogue or ignore content to focus on extraneous sounds, you won't be able to make important decisions regarding sound—the very reason you've been hired!

FIELD MIXER OPERATING TECHNIQUES

Critical listening is perhaps the hardest part of your job. Pretty much all of the crew is obsessed with what the shot looks like and the content of what is being delivered. Whether the sound is usable during recording is the responsibility of the location sound operator. No one wants to hear that the perfect take is unusable because of a sound issue. In fact, I think most of the crew members actually think it's my fault that an ambulance went by with sirens blaring.

So what does good location audio sound like? Well, if what you hear in your headphones sounds great then it probably is. If it sounds like !?#*! then it probably is.

Move through this section carefully. My mom always said to me, "I know you can hear me, but are you listening?" It's time to learn how to listen.

LISTENING EFFECTIVELY

A common mistake made by location audio operators is that they try to listen to too many things at once. Your responsibility, and your job, requires you to focus your listening on the tonal quality of the voice, the ambience for fluctuations, and for offending extraneous sounds—but not all at the same time! It's impossible to focus on everything at once.

Therefore, by breaking up these vital listening areas throughout setup, rehearsal, and recording, it becomes easier to manage and focus on each one individually.

Here's how to listen.

DURING SETUP: FOCUS YOUR LISTENING ON THE AMBIENCE OF THE LOCATION

Figure 4.30

The general ambience of the location is the first thing you should focus your listening on. Chapter 2, "Choosing and Preparing a Location," explains exactly how to handle your findings. During the hellos and load-in, you should focus your attention for at least five minutes on the ambience of the proposed location (without your gear). You're listening for fluctuations in the ambience that are both subtle and extreme.

After you've fixed all ambience concerns, put your gear on and listen for at least one more minute. Critically listen for fluctuations in the ambience. The ambience must be constant (think of a fan—its humming stays constant), consistent (the types of sounds stay the same), and not too loud (it won't compete with the dialogue).

If the crew is being too loud during your final evaluation, ask everyone to be quiet for a moment. Hopefully it's a good location, and you've dealt with any ambience issues when you prepared the location, but if you hear any fluctuations during this final listen, this is the time to fix it.

DURING REHEARSAL: FOCUS YOUR LISTENING ON THE TONAL QUALITY OF THE DIALOGUE AND SEPARATION FROM THE AMBIENCE

During rehearsal is the time to get the tonal quality of the dialogue sorted out. This is where you implement the dialing-in procedure laid out earlier in this chapter. Your critical listening is during mic placement (to achieve sound perspective) and the setting of the high-pass filter (to create dialogue separation from the ambience).

If you've chosen and prepared your location properly, this won't be an issue. But if you find the ambience is competing with the dialogue once talent starts to speak during rehearsal, it's vital you bring it to the attention of the decision makers. They may want to change locations even though setup is complete.

During rehearsal you'll be busy making very important decisions. Here are three key listening elements that you'll need to accomplish before you start recording.

Element 1: Separation between the dialogue and the ambience.

Element 2: Dialogue matches the perspective of the frame.

Element 3: The recording has a consistent ambience bed.

Element 1: Separation between Dialogue and Ambience

A good location recording has separation between the dialogue and the location's ambience. The dialogue should sit on top of an ambience bed that is rich with sounds that make the viewer feel like they are there. The tricky part is knowing how much ambience is enough before it starts to distract from the dialogue.

I use my meters to help make this decision. I like to have a minimum of 16dB between the ambience bed and the talent talking. So for me to operate between −2 and +8 on a PPM meter the ambience bed should never exceed −18dB (that's a pretty loud ambience bed). I find that in most locations where dialogue is being recorded (interviews, scenes) the ambience bed is down around −30dB.

If the ambience creeps up around −12dB I'm probably recording in a loud location (a factory), and the talent is having to speak loudly to get over this type of ambience.

Element 2: Dialogue Matches Perspective of Frame

When focusing on the talent's voice, it should have a tonal quality that follows the perspective of the frame. For example, a tightly framed shot should have little ambience, sound close, and tonally be very warm. Just like when you are standing close to someone. A medium wide shot should have more ambience, sound farther away, and be tonally thinner sounding (less bass). Just like when someone is standing one to two meters away.

You want the sound to move with the shot. It sounds great when you cut from a CU (close up) that sounds warm and close to a medium shot that sounds thinner and has more ambience. Pay attention to the framing for each shot. If the camera is zooming in, boom closer as the picture tightens up. Watch the camera operator's lens or ask to see the LCD screen during recording.

You'll see them zoom in and out, and you can follow if you're paying attention. You're not making drastic changes but subtle ones. In fact, most people won't even notice. But matching tonal quality to the frame will contribute to the overall quality of your work and help you build a reputation of providing audio that just simply sounds better.

Figure 4.31 Framing: close-up, or CU

FIELD MIXER OPERATING TECHNIQUES

Figure 4.32 Framing: medium

Element 3: Consistent Ambience Bed

A consistent ambience bed is also a sign of good location audio. By not making huge changes in volume, tone, or swapping microphones during a scene, you will have a better chance of keeping the ambience bed consistent. Operators that are constantly changing mics, putting in PADs, and flipping through high-pass filters are killing the post audio editor, because they're changing the ambience from shot to shot.

I find that by choosing the proper mic and deciding on mixer settings at the beginning of a scene, and staying very close to those decisions throughout the entire scene, the ambience bed stays consistent. I'm not saying I won't sacrifice a consistent ambience bed if I'm getting killed by shouting talent entering a scene, but I find that a majority of the time the correct mic and a properly dialed-in mixer at the beginning of a scene, with minor volume changes when needed, will get me through the entire scene and produce the most consistent ambience bed.

There's a lot for you to focus your listening on during rehearsal. This isn't the time to be chatting with talent or grabbing a drink. The critical listening during rehearsal will make or break the quality of your recordings.

DURING RECORDING: FOCUS YOUR LISTENING ON EXTRANEOUS SOUNDS

When you're recording, you must be listening for extraneous sounds. Your full and undivided attention is required to make quick decisions every time an unwanted sound occurs. You must focus your listening on the ambience, not the dialogue. You're not making decisions based on content—if a word is mumbled, or if talent got the dialogue correct—that's the directors job. You're focusing your listening 100 percent on the ambience, on what's going on behind the dialogue.

Is a retake needed? That will be the question you'll be asked if an extraneous sound occurs. You need to be prepared to answer, and you'll base your decision on this very simple example.

If a loud sound happens on top of dialogue, the take is no good. If the same sound occurs in a gap between sentences or even between words, it may be possible to remove it during editing.

It's your responsibility to listen for all extraneous sounds during recording and decide whether a retake is needed.

Make the Call

In my experience, it's a close 50/50 split of extraneous sounds that can be edited out. You need to be 100 percent sure the take is usable. If you're not 100 percent sure, ask for another take.

You'll need to be strong on this request, because the director is not going to be happy if the take was great visually. Never let it slide, and *never* say, "It should be fine" just because you're being questioned—don't waffle on your request.

Constant and unnecessary interruptions during a take are frustrating for everyone. If you ask for a retake every time a minor sound occurs, you'll soon be labeled as a "pain in the butt" and you'll end up being tuned out.

Learning when to step in and when to keep the shoot moving is a valuable skill. The more experience you have, the better you'll get at it. There's no quick way to learn it—it just takes time and 100 percent focus.

CONTENT OF YOUR DEMISE!

Allowing yourself to get caught up in the content of an interview or written dialogue, no matter how fascinating, will lead to the end of your career. Believe me, by being distracted you'll miss important sound issues vital to whether a shot is acceptable. You won't be doing your job.

Figure 4.33

If you find you're much more interested in listening to content, or following along with scripted dialogue, perhaps you should put down the boom pole and become a director or script supervisor! Remember, this is video not film. There's no rotund fellow sitting behind a Nagra or DAT machine reading the latest edition of *Mix* magazine making decisions for you. Wow, did I just date myself!

TRAINING YOUR EARS

To train your ears and make the correct decisions to achieve quality location audio recordings, you'll need to talk your way into as many editing sessions as you can. Listen to the good and bad of your recordings. I know most operators haven't heard a majority of their recordings—I was one of them! It's pretty difficult to improve your skills if you rarely hear the finished product. Speaking from experience, this is one thing I would have done earlier in my career to develop my skills faster.

Over time, you'll learn how the sound you are monitoring in your headphones is going to translate to the television, Internet, podcasts, etc. You may be surprised at what sounds are most problematic. If you know someone who is a post audio editor or who owns an edit suite with a pair of decent monitors, ask if you can bring in some recordings to critique. Have the editor listen to the recordings and give suggestions on what would help with the post work.

In video, large and costly post budgets are rare. The sign of a good location recording is one that edits together easily with the least amount of audio sweetening.

Figure 4.34 I use Sennheiser HD 25 headphones—expensive, but worth every penny.

HEADPHONES

Finally, to assure you're hearing what's really going on, I strongly suggest you invest in a pair of high-quality headphones that are designed specifically for location audio. I've stated this earlier, but your headphones are providing you with the most important information needed for recording quality audio. You don't want to cheap out here.

Do not use home stereo headphones—even if they are very expensive. Not only will they color the sound giving you an inaccurate representation of your recording, but mother nature will probably kick the crap out of them.

FIELD MIXER OPERATING TECHNIQUES

Task #5—Shooting

Making adjustments to the mixer during recording.

Everything up to this point has been preparing you to record quality tracks. Your mixer is ready to go, you know what to listen for . . . and now you're recording.

Well, I hate to rain on your mixing parade, but there's actually not much to be done to the mixer once the camera is rolling. The only mixer adjustments will be to increase or decrease channel faders, and switching the monitor return back and forth between mixer and camera. That's it!

Figure 4.35 Only mic adjustments when you're working this way!

With a proper initial setup and dialing in, the mixer is taking care of everything, and your operating focus turns more to booming (mic placement) and listening than mixer function adjustments.

So let's not get all long-winded and try ro make more out of this than necessary. You've got a couple of responsibilities now. Let's take this time to remind you what they are and show you how to apply them.

VOLUME CHANGES

If volume changes are necessary to bring the mixer back into unity range, make them quickly and try to do it between sentences. There's nothing worse for a post audio editor then a slow increase in volume over a complete sentence. You won't know if the sentence will be kept in its entirety or be sliced up. A slow creep, when edited, can produce a whole bunch of volume changes—more work in post.

I find that my operating volume is usually set after a couple of questions during an interview or a couple of rehearsals when shooting a scene. With professional talent you'll find they project more and often get louder—I'll have my volume set quite quickly.

With nonprofessionals, you're going to have to pay attention especially during interviews. Talent can get more nervous and speak softer, some will get really loud, and others are up and down like a yo-yo. I find it takes a little longer to get my volume correct, but once I'm set for a few questions, I'll leave it alone. Don't volume up and down during the entire interview—you're not helping anyone.

With a scene, try and find a volume that gives a little headroom to increase or decrease the channel volume (say 1 o'clock). Once you've been through a drama with nonprofessionals, you'll come to love the pros—they're way more consistent in every aspect of their performance when shooting.

CHECK MONITOR RETURN

As I stated earlier, I'll flip between listening to the mixer and listening to the camera or recorder with the monitor return function many times throughout a take. In a 20-minute interview I'll easily switch 10 times or more.

SECOND SET OF EARS

During thousands of hours of recording, you will miss the odd extraneous sound. I find that if the camera operator is glancing at me with that "should I stop recording?" look, I may have missed something. Or if an extraneous sound occurs that borderlines on acceptable, and they glance at me with the "did you hear that?" look, it can help me make the decision for a retake.

FIELD MIXER OPERATING TECHNIQUES

By conferring with the camera operator about a possible sound problem, you are not deferring to the operator for a decision. You're acquiring more information to make the decision.

This is like when the camera op shows you the video monitor, not to ask you to decide whether the composition or lighting is good but if anything is distracting. I've pointed out many C-stands and camera bags in the shot.

Figure 4.36 When shooting, the more ears the better. Everyone's wearing headphones.

I will always ask the camera operator to wear headphones and monitor the sound at the camera. I carry a couple of inexpensive sets of earbud headphones and give them away to operators that don't use or have headphones. Camera ops that aren't used to wearing headphones find earbuds more comfortable than full headphones. Bottom line, get them to wear headphones. A second opinion when you are not 100 percent sure of a retake can help.

Figure 4.37

FIELD MIXER OPERATING TECHNIQUES

Some camera operators are used to wearing headphones and prefer to, stating the audio information often dictates the need for a push-in or widening out of the frame.

Figure 4.38

A video shoot is team work, so shelf the ego for the good of the production.

Watch Class 9—"Operating a Field Mixer."

Room Tone Is a Must!

Room tone is a "voice-free" natural sound recording of the location that will be used extensively to smooth audio edits during post. Make sure to gather this ambience track from the same spot in the room where the recording took place.

If I've just recorded an interview, I'll keep the talent sitting and boom as if the interview was still being recorded. By recording right after the interview is completed, I ensure that the room will be tonally the same.

When recording room tone do not adjust the mixer in any way! You want the room tone to match the ambience of the interview or scene in volume and tone.

During a shooting day, this is the one time that you, the sound operator, get to call the shot! Yes, you heard me right—you'll inform the crew you're recording room tone.

I've found that asking for room tone is usually met with a chorus of moans and the "is this really necessary?" look, followed quickly by "we haven't got time." So the solution

is, *don't ask*. Make a statement something like this: *"Quiet please for 30 seconds of room tone. Camera tilt up and shoot the mic. Roll camera!"*

You'll be surprised how people will just follow the order. It prevents the "we don't have time" conversation and gets the room tone that you need—recorded properly.

The reason for the camera to focus on the mic during room tone is that it's the visual indicator to the editor that there is an ambience track recorded. Do not let the camera operator shoot cutaways or b-reel—the editor will never know the room tone is there.

Make sure you record a minimum of 30 *uninterrupted* seconds of room tone—sometimes it can take 60 seconds or more. If I've had issues with a certain sound like a car, wind, or a plane in my ambience during an interview or scene, I'll make sure I have some of that sound in my recording of the voice-free room tone as well. This can sometimes mean you have to record a little more than 30 seconds or wait and record that specific ambience when the location is quiet and you can take more time.

Always record room tone—never leave a location without it.

Watch Class 10—"Room Tone."

CHAPTER 5

Shotgun Microphones

There Is No Other!
Shotgun Microphones: Characteristics and Groups
Group 1: Hyper-Cardioid Microphones
Group 2: Short Shotgun Microphones
Group 3: Medium Shotgun Microphones
Group 4: Shotgun Microphones
Pick-up Pattern Width
Powering a Shotgun Mic
Low-Cut Filter on a Shotgun
Axis and Lobeing
One Final Thought

There Is No Other!

There's nothing like the sound of a shotgun microphone. The warmth, transparency, sound perspective, and rich ambience beds are qualities only shotgun microphones can produce.

When used to their full potential, a single, quality shotgun microphone is all you'll need for most video production shots. I use *one* shotgun microphone for over 90 percent of my recordings, and so can you—if you learn how to use it properly.

THE TRUTH ABOUT SHOTGUNS

I'd like to tell you they're easy to use, but that's not the case. You don't just point them at the talent's mouth and it sounds great—no chance. In fact, it's quite the opposite. If used incorrectly, shoguns can screw up a recording beyond repair.

SHOTGUN MICROPHONES

Figure 5.1

Figure 5.2

An untrained sound operator will struggle to produce even passable recordings with shotgun microphones. Not because they aren't trying, but because they just don't understand how they work and how to apply them.

I've met many frustrated location sound operators who've given up on shotguns and rely solely on lavaliers—that's sad.

In this chapter I'll define the mic groups that make up our shotgun arsenal, describe their characteristics, limitations, and effective working area—then provide possible applications.

SHOTGUN MICROPHONES

Shotgun Microphones: Characteristics and Groups

Shotgun microphones have evolved slowly over the years, and I've found most sound operators to be quite loyal to a specific brand, even a certain pick-up pattern. As you become comfortable with the characteristics of your shotgun microphones, you'll understand where this loyalty comes from.

THE PICK-UP PATTERN

Shotgun microphones are designed to cut through ambience and hone in on the sound you want to record. How far the microphone will reach and how wide an area it will cover is determined by the microphone's pick-up pattern.

With shotgun microphones, the width of the pick-up pattern can be determined by the cuts or ports on the side of the microphone, called *cancellation ports*. The more ports the microphone has, the tighter the pick-up pattern will be. Consequently, there will be more cancellation of the near field surrounding ambience, and the microphone's ability to reach sounds further away increases. Fewer ports will widen the pick-up pattern but decrease the microphone's range.

Figure 5.3

By knowing the width and range of a shotgun microphone's pick-up pattern, you'll know which microphone to choose for the shot. The following groups will help you choose the correct mic.

Group 1: Hyper-Cardioid Microphones

Used primarily for dialogue indoors, the hyper-cardioid group of mics has a very wide pick-up pattern—allowing you to easily record a single person as well as a group of people. See Figure 5.4. This wide pattern is very forgiving when the talent moves or turns their head away from the mic. Hyper-cardioid microphones will have a tight, warm sound when booming at their minimum range of six inches from the talent, and a thinner sound moving the talent further into the ambience when booming at the end of its range of about two feet.

Since most shots in video production are close and medium, you could get away with a single hyper-cardioid mic due to the fact that the top of frame rarely pushes the mic further then one foot above talent.

Figure 5.4 Hyper-cardioid microphone—very few cancellation ports

SHOTGUN MICROPHONES

The hyper-cardioid group of mics are used primarily indoors, leaving outdoor recordings to the Group 2 short shotgun mics. But I disagree with this pigeon-holing of the hyper-cards—I've used one for over 15 years in some of the harshest outdoor locations, and the recordings are nothing less then fantastic! I'm not sure where this indoor-only label came from, but I don't buy it.

Hyper-cardioid mics also work great for following the camera's perspective without physically moving the mic too drastically. Be sure to stay within the microphone's six-inch to two-feet range.

Neumann KM 150 is a professional series hyper-cardioid microphone, and it sounds fantastic. These mics are pricey and require a full Rycote suspension, adding to the cost, but in my opinion they're well worth it. See Figure 5.5.

For a good cost-effective alternative, the Sennheiser ME 64 (cardioid pattern) does a great job, and it doesn't require a full Rycote suspension. A simple doughnut shock mount with a softie windsock will do the trick, and it's a quarter of the cost. See Figure 5.6.

Figure 5.5 Neumann KM 150

Figure 5.6 The Sennheiser ME 64 mounted on a camera

93

SHOTGUN MICROPHONES

Figure 5.7

Group 2: Short Shotgun Microphones

Although the short shotgun group of microphones often have a hyper-cardioid pick-up pattern, it's not considered part of the hyper-cardioid group. Even though it's referred to as short, the physical size of the mic is larger than its smaller brother in the hyper-cardioid microphone group—still with me?

The short shotgun mic's range is from six inches to two feet and is primarily used to record dialogue outside.

Just like the hyper-cardioid group of microphones, the short shotgun microphone will bring the talent closer to the viewer at its minimum range of six inches, and make the talent seem further away at the end of its range, two feet.

There are many sound ops who would say the short shotgun group of mics shouldn't be used indoors. Well, I'm not sure what I'm doing differently, but unless I find myself in a very live room (a lot of reverb) or close to walls or a low ceiling, I've had no problems recording quality tracks indoors with a short shotgun microphone.

DPA4017B, and Sennheiser MKH50 are the professional series versions, and the Shure VP89S, Sennheiser ME 66, and Rode NTG2 are excellent entry-level short shotgun microphones.

Figure 5.8 Short shotgun microphone

Figure 5.9 Shure VP89S

Group 3: Medium Shotgun Microphones

Figure 5.10

SHOTGUN MICROPHONES

Used primarily for dialogue outside, the medium shotgun is needed when the shot gets too far away for the short shotgun category of mics to reach.

The medium shotgun mic's range is from 1.6 inches to 4 feet and will bring the talent closer to the viewer at its minimum range of 1.6 inches, and make the talent seem further away at the end of its range, 4 feet.

Neumann KMR81i, and Sennheiser MKH60 are the professional series versions, and the Shure VP89M, Sennheiser ME 66, and Rode NTG3 are standard entry-level medium shotgun microphones.

The medium shotgun group of microphones are my choice for capturing ambience tracks as well as a medium-framed walk-and-talk. I like the width of the pattern at two feet to three feet, which allows me to stay well clear of the top of frame while giving me room for booming errors.

Figure 5.11 Medium shotgun microphone

Group 4: Shotgun Microphones

The shotgun microphone has a very tight pick-up pattern for maximum cancellation of ambience. This tight pattern gives the mic excellent reach, so when a big wide shot is framed up you can still record crystal-clear dialogue.

If there is excessive ambience, the shotgun mic does an excellent job of cutting through and honing in on the dialogue. The shotgun group of microphones have a minimum range of four feet, and I've been successful recording dialogue at ten feet. However, due to its tight pattern you need to be very accurate when booming.

Figure 5.12 Shotgun microphone

Figure 5.13

The shotgun group includes big wide-shot mics that are more suited to slow-paced film-style shooting.

Neumann KMR82 and Sennheiser MKH70 are the professional series of shotgun microphones most widely used, and they are quite expensive. The Shure VP89L and Rode NTG8 are great entry-level models.

You need to be very accurate when using a shotgun category microphone.

In my opinion, Group 3 shotguns are just too physically big, and the pattern is too tight for video production. From an operating perspective, they're much too heavy for many of the booming techniques required on a nonscripted, flying-by-the-seat-of-your-pants video shoot. You'll get burned over and over because of the mic's extremely tight pattern.

Watch Class 11—"Shotgun Microphone Basics."

Pick-up Pattern Width

The various mic groups have width to their pick-up pattern. The width is your saving grace and will allow for booming errors. A mic with a wide pattern will be more forgiving than a tighter pattern mic. Group 1 mics have the widest pattern, Group 4 mics the narrowest.

As you move closer to a shotgun mic's maximum range, the pick-up pattern will be at its widest. This is vital for when you're trying to capture unscripted conversations or groups of people. But remember, at the widest part of the pick-up pattern's width, you'll also be increasing the amount of ambience on your recording—it's a balancing act.

SOUND PERSPECTIVE

An important quality you can add to your recording is sound perspective. As there is visual perspective for a viewer's eyes, so there is sound perspective for their ears.

Bringing the sound closer for intimate close-ups or moving the sound further away for wider shots will add a wonderful dynamic to the final product. You can maintain cohesive perspective with the picture by booming closer to the microphone's minimum range for tight shots, and closer to its maximum range for medium to wide shots.

When you are closer to the minimum range the dialogue should sound warm, have more bottom end, and sound like the person is close to you. When you boom closer to the mic's maximum range, the dialogue should be thinner, have more mid frequencies, and sound like someone is a few feet away.

Try this out—you don't need gear. Get a friend to read a paragraph of something. Stand quite close to (a foot away), then take a step or two back while your friend reads.

If you focus on the tonal quality of the voice, you will notice it gets thinner and the bass drops off as you get further away. You'll also notice the ambience of the room will seem to increase, even though it doesn't.

This sound perspective is what we want to achieve as the framed shot tightens and widens. This maintains the relationship between sound and picture. Way cool!

PICK-UP PATTERN RANGE

I don't know the exact minimum and maximum ranges of all the shotguns on the market. The ones I've suggested I have used extensively and found these distances to work well for creating sound perspective. You should do a little experimenting with your own mics to find their ranges.

Here are a few situations that can change the range of any shotgun mic:

- When recording outdoors, the microphone's maximum range can increase significantly depending on the amount of ambience. In a quiet outdoor location like an open field, where there are very few reflections (echo, reverb), a Group 1 short hyper-cardioid mic can sound quite tight when booming as far away as three feet.

- When recording indoors, it's critical to stay within the mic's maximum range. How "live" a room is (a live room has a lot of sound reflections) can easily cut the maximum range of any mic in half. Be very aware of reverb and echo on your recordings—for most dialogue recording they are no good.

- Never jam the mic's range when trying to get more volume from a quiet talker. By jamming the mic's range (that is, booming closer than the mic's minimum range), the voice can enter the cancellation ports as well as the pick-up pattern of the mic. This can cause all kinds of weird phasing. I've heard some pretty funky sound when the boom op jams the mic's minimum range.

Watch Class 12—"Sound Perspective with Shotguns."

Powering a Shotgun Mic

All shotgun microphones require a power source to work. So if you want to plug a shotgun mic directly into a camera, be sure the camera supplies power to the microphone or the microphone uses batteries. You can power a shotgun mic in three ways:

1. 48PH—phantom power from a mixer: 48V phantom is the industry standard for powering microphones. All professional cameras supply it and most prosumer cameras will as well. All mixers will supply 48V phantom.

2. 12T power from a mixer: Early Sennheiser microphones use 12T power, and most mixers will have this type of mic power. I have yet to work with a camera that supplies it.
3. A battery installed in the mic: If you want to plug a shotgun mic directly into a camera, you may need to have a battery powered mic. Shotgun microphones that use batteries can also be powered with 48V phantom.

If your mic uses a battery, take it out and use the 48V phantom from your mixer. You'll never get burned by a drained mic battery.

Low-Cut Filter on a Shotgun

Some shotguns have a low-cut filter or bass roll-off on the barrel of the mic. When switched on, it cuts the low frequencies from the signal.

In location audio I find this function useful for reducing handling noise. There are shotguns out there that are so low-end sensitive you can barely touch the boom pole without causing a thumping sound.

To be honest, I stay away from these super-low-frequency–sensitive mics. They sound great if mounted on a mic stand, but I find you can't boom without the low-cut filter having to be turned on, and this negates the control I have with the high-pass/low-cut filter on my mixer.

The perfect application for shotguns with a low-cut filter is as a camera mic. With the low cut turned on, it gets rid of the camera operator's handling noise, and it does a good job of cutting down the low rumble cause by the wind.

I use a Sennheiser ME 64 with the low-cut filter turned on as a camera mic—it's perfect.

–10DB PAD ON A SHOTGUN

Another switch you might find on a shotgun is a –10dB PAD. In loud locations or sounds with high SPLs (sound pressure levels), mics can distort from excessive levels. The PAD can prevent this.

Whenever I'm recording a loud sound like someone singing or shouting, or I'm working in a loud venue such as a concert, sporting event, or convention, I automatically

Figure 5.14 Shotgun with low-cut filter and –10dB PAD

SHOTGUN MICROPHONES

put the –10dB PAD in—every time! This prevents distortion at the mic and reduces the signal to a level my mixer can easily handle.

Watch Class 13—"Shotgun Microphones Low-Cut Filter and PAD."

Axis and Lobeing

Shotgun microphones have two distinct areas to their pick-up pattern: the axis and the lobe.

The *axis* is a small area in the center of the pattern about ten inches wide within the mic's range. The *lobe* is the width of the pick-up pattern (not including the axis) within the mic's range.

These two distinct areas of the pick-up pattern will effect the volume as well as the tonal quality of the sound. So where you point the mic can change the sound dramatically. See Figure 5.15.

Figure 5.15

AXIS

Recording on axis (pointing the axis of the mic's pick-up pattern directly at the sound source) will give the optimal gain and maximum cancellation that the mic offers. If you point the mic directly at the talent's mouth, the voice will be its loudest, therefore pushing the ambience back.

SHOTGUN MICROPHONES

Applying the Axis Technique

Recording "on axis" is a technique commonly used when working in film. Mixers in film want the dialogue to be as loud as possible with the least amount of ambience. See Figure 5.16.

Booming on axis requires the operator to be very accurate to achieve a quality dialogue recording. If the talent is constantly moving in and out of the mic's axis and into the lobe portion of the pick-up pattern, there will be noticeable changes to the volume and tone of the voice.

Recording "on axis" can be achieved with scripted dialogue, but if you're trying to follow a nonscripted conversation, booming this way will produce poor results.

The only time I record on axis is during a sit-down interview when the talent has a super-soft voice.

Figure 5.16 On axis

LOBEING

Lobeing is when you point the lobe portion of the microphone's pick-up pattern at the sound source. Since the lobe is the majority of the mic's pick-up pattern, the accuracy needed when booming is in your favor.

Applying the Lobeing Technique

To record using the lobeing technique, I point the axis of the mic at the bottom of the talent's sternum (the center of the chest, for those who are anatomy challenged). See Figure 5.17. This makes the lobe portion of the pick-up pattern focus around the talent's

SHOTGUN MICROPHONES

head. Most of the unpredictable movement will be from the head, but the talent's chest will move slowly and more predictably, making it easy to keep the axis of the mic focused on an area. When the axis of the pattern stays consistently focused on a single surface, it helps keep the ambience of the location consistent, cuts down reflections, and keeps the voice tonally even—what more can you ask for!

> *The lobe does not have the gain that recording on axis does. You will get more ambience.*

Figure 5.17 Lobeing

The Only Way to Go

In my opinion, lobeing is the only way to achieve consistent dialogue recordings when you are booming and mixing simultaneously. By keeping the mic out in front of talent and letting the mic do its job, booming errors will be few and far between.

As an added bonus, lobeing provides increased richness to the lower frequencies of the talent's voice. These low frequencies resonate off their chest, resulting in a warmer, richer sound.

And to sweeten the pot a little more, by slightly moving the axis off the talent's chest you can change the sound perspective from warm and close (perfect for a close-up), to thinner and further away (perfect for a medium shot).

One Final Thought

The cancellation ports on a shotgun are very powerful. The more you learn how to use them properly, the more versatile a single shotgun mic becomes.

SHOTGUN MICROPHONES

In my opinion, there's no reason for a video location sound operator to be carrying a full arsenal of shotguns mics. A Group 1 mic and Group 2 mic is all you'll need to record quality tracks in video production.

Learn how to use the mics you own, or choose a brand and learn how to use them properly, and then send me a check (only 50 percent) of all the money you've saved by not buying into the "I need all these mics to be successful" hype.

Watch Class 14—"Shotgun Microphones: Axis and Lobeing."

CHAPTER 6

How to Boom

A Booming Introduction
Prepping and Wrapping the Boom Pole
Operating the Boom Pole
Static and Motion Booming
One-Hand Booming
Never Pass Through the Axis!
Booming the Sweet Spot
Scooping
Booming Quick List

A Booming Introduction

Learning how to operate a boom pole will be the toughest technique you need to master before heading out to a location. If done correctly, you'll be amazed at the results. Done incorrectly, it'll ruin your recording. As you become familiar with these booming techniques, you'll quickly discover that the boom/shotgun combination yields the best recordings on location.

Figure 6.1

HOW TO BOOM

Learning how to boom is no easy task.

If you watch professional video sound operators, they make it look easy. They move around like nothing is really going on. They're relaxed, and the boom pole appears to be an extension of their arms. If you've never operated a boom pole, you're in for a bit of a shock.

The mechanics of keeping the mic focused on the talent while operating a mixer, maybe throw in walking backwards, and topping it off with guiding the camera operator as he or she walks backwards, requires a lot of practice and skill.

Yes, strength is a part of it, but you don't have to have superhuman arms of steel to wield a boom pole. Booming is more about balance and technique.

Figure 6.2A

In this chapter, you'll learn how to extend and collapse the boom pole, move fluently with talent, and survive those long exhausting interviews. But first we need to get you looking like a professional location sound operator.

Figure 6.2B

Prepping and Wrapping the Boom Pole

Don't skip over this!

I put this first because there is nothing more embarrassing than getting tangled and tripping on your own cables, or having the boom pole slam down on your hands. The

rookie location audio operator sticks out like a sore thumb largely because of boom pole and cable woes. A poorly wrapped cable on the boom pole will rattle against the pole when moving, get caught in your gear, and tangle up into a messy doughnut twist. An improperly prepped boom pole will have you unable to loosen or tighten the collars/knuckles, causing nothing but embarrassment.

There are some easy solutions to get you looking like a pro quickly, but operating like one is going to take some hard work and a lot of practice.

If you're just starting out, grab a boom pole and follow along. I'll save you much embarrassment. If you've been operating for a while, read on—you might learn something new!

PREPPING THE KNUCKLES/COLLARS

To efficiently extend and collapse the boom pole, you first want to prep it. To do this, loosen the biggest or bottom knuckle of the boom pole first. Extend the section of boom pole above that knuckle about 2 inches—this will be the area you need to grip to loosen the next knuckle. Tighten the knuckle. Do this with each section of your boom pole until it looks like the boom in Figures 6.3 and 6.4.

As you'll learn, you'll end up more than once with the knuckles turning forever and a boom pole you can't seem to tighten. This prepping of the boom pole will help prevent embarrassment.

Figure 6.3

Figure 6.4

HOW TO BOOM

Figure 6.5

CONTROLLING THE BOOM CABLE

For wrapping the boom pole, first extend the boom pole to the desired length for the shot. Then let out a few coils of XLR cable and connect to the shotgun mic. Now, stand the boom pole straight up (if there's enough ceiling height) and let out enough XLR cable so the cable runs from the mic, down to about four inches from the ground, then back to your Velcro tie. See Figure 6.5.

By letting your boom cable out this way, the cable never touches the ground, which is good if you're working in a muddy location. Also, the length of cable from the Velcro tie down to your foot is the perfect length of cable when you raise your hands and fully extend forward—no extra cable getting dirty or getting in the way.

To wrap the XLR cable around the pole, lift the boom pole a couple of feet off the ground and throw the XLR cable around the butt end. Never spin the boom pole! Spinning the pole will create twists in the cable. Three or four throws around an eight-foot boom pole is sufficient—don't wrap it up like a mummy.

Snug and secure the cable on the boom pole by pulling it tight then gripping it with the hand that's on the butt end of the boom pole. See Figure 6.6.

The XLR cable must be snug the entire length of the boom pole to prevent the cable from rattling against it. See Figure 6.7.

Figure 6.6

Figure 6.7

EXTENDING THE BOOM POLE

Always extend the boom pole from the smallest or top knuckle first. Fully extend that section before moving to the next knuckle. By keeping most of the weight of the boom pole in your hands, the pole will be much lighter. Collapse the pole from the largest or bottom knuckle first, making your way back to the top knuckle of the pole—collapse it back into the prepped state. See Figure 6.8. It will be easier to extend again.

Watch Class 15—"Boom Pole Basics."

Figure 6.8

GRIP AND STANCE

To set yourself for the proper grip, hold the boom pole down by your waist with your right hand on the butt end of the pole, your palm in, and the left hand further up the pole about shoulder width apart, palm out. See Figure 6.10. Your arms should be no further than shoulder width apart or you'll lose the ability to move the mic forward and backward.

Figure 6.9

Figure 6.10

HOW TO BOOM

Raise the pole above your head and look straight down the pole, keeping your head up and your body at a 45-degree angle to the talent. See Figure 6.11. The boom pole should be directly over your head. I crank my front wrist like I'm holding a tray to allow a clear view of the microphone. This will help you see where the mic is pointing.

The shaft of the boom pole rests on the pads of your fingers. See Figure 6.12.

Figure 6.11

Figure 6.12

For added stability, place the thumb of your back hand underneath the pole. See Figure 6.13.

Figure 6.13

HOW TO BOOM

Do not put a death grip on the boom pole! Grip it gently.

Booming is a gentle fluid art. Learn to relax when booming, or you're going to have a tough time making it through a 2-minute shot, not to mention an unexpected 20-minute interview. Learn to relax.

TIP! It's good practice not to let the butt end of the boom pole touch the ground. The first time you work in the mud, it's going to end up everywhere. The trick is to place the butt end of the pole on the toe of your right foot. This will keep it out of the dirt. See Figure 6.14. Then, by tipping your foot backwards and resting the shaft of the boom pole on the inside of your shoulder, both your hands are free to wrap and unwrap cables.

Figure 6.14 Keepin' it clean

Watch Class 16—"Booming Techniques."

CHOOSING A BOOM POLE

Using the right boom pole for the job is important. Boom poles come in various lengths, from 5 feet to 20 feet, and they are made from either aluminum or carbon fiber. Which pole you choose depends on the type of shooting you're doing.

If you are doing ENG (electronic news gathering) or documentary shooting, you'll want a four-stage boom pole that collapses down for easy packing and transport. I'd suggest a lighter carbon fiber pole for one-hand booming and long interviews. It should also be short so you can operate in small quarters.

The shorter the pole, the lighter the load's going to be when fully extended. But don't go too short, or you won't have enough reach for a medium shot. If you're a little weak in the arms, an 8-foot boom pole (fully extended) is the minimum length you should choose. I wouldn't go any shorter. I find for ENG and documentary-style shooting, a four-stage 11-foot carbon fiber pole is perfect for the job.

Figure 6.15

If drama is more your focus, you'll probably need two boom poles: a long 16-foot to 20-foot aluminum pole for the big shots, and a medium 9-foot to 11-foot carbon fiber pole for the rest.

The longer pole should be aluminum because it will bend less, making it easier to operate when fully extended. It is a bit heavier, so strength is required for the big shots. It's also

Figure 6.16 Internally cabled boom pole

a good idea for this pole to be three-stage, to add to the rigidity (less knuckles), and it's a little cheaper in cost. The second boom pole will be your workhorse pole, and it can be either aluminum or carbon fiber (it's your choice). I recommend that this pole be a four-stage pole, so it collapses down quite small when the working area gets tight.

Operating the Boom Pole

When booming you need to be able to move the boom pole forward and backward, up and down, and to change the pitch of the mic as well as the angle, all fluidly and accurately. When you're stationary, these motions will greatly improve your accuracy. When it comes time to move your feet during a walk-and-talk or "scrum" (when news

HOW TO BOOM

reporters gather around talent for a story), these motions are an absolute must for getting the shotgun mic in the position it needs to be.

MOVING FORWARD AND BACK

The forward and backward movement of the boom pole, when done correctly, should add about five feet to your reach. You need to move fluidly, or the mic will bounce. Stand in one spot with the proper grip on the pole with your arms in this position, I call this the neutral position. Your arms should make a "U" shape. See Figure 6.18.

Figure 6.17 My perspective

When you are extended fully forward, the height of the boom pole should not change. Your right arm will be slightly across your face, and you should still be looking straight down the pole. See Figure 6.19.

When pulling the boom backwards, your left arm will travel in front of your face, still keeping the pole above your head at the same height, and looking straight down the pole. See Figure 6.20. Remember to keep your body at a 45-degree angle to your target.

Figure 6.18

HOW TO BOOM

Figure 6.19

Figure 6.20

> Handling noise *is a thumping sound that occurs when you are gripping the boom pole too tight—it will ruin a take and can be difficult to repair in post.*

RAISING AND LOWERING

Moving the boom pole up and down is easy, but you'll do it a lot. Extending your arms up is needed when you pass over the top of the camera operator or clear objects without changing the pitch of the mic. Bringing them down to chest height works great for an interview, or when the shot goes long and you need to relax your shoulders. See Figures 6.21 and 6.22.

HOW TO BOOM

Figure 6.21

Figure 6.22

CHANGING THE PITCH

To change the pitch of the mic, you need to raise and lower the hand on the back of the boom pole, keeping the front hand at the same height or higher. If you lower your front hand, the shaft of the boom pole could possibly enter the frame, ruining the shot. This motion is needed if the talent starts speaking to his or her shoes and you need less pitch to the mic, or when you're fully extended forward and you need more reach. See Figures 6.23 and 6.24.

113

HOW TO BOOM

Figure 6.23

Figure 6.24

CHANGING MIC ANGLE

By twisting your right hand while holding the boom pole, you can change the mic's angle from right to left. The pole rolls gently on the pads of your fingers of the front hand, keeping handling noise to a minimum. If you're gripping the pole the way I have described, you should be able to point the mic from 4 o'clock to 8 o'clock with ease. See Figures 6.25, 6.26, and 6.27.

HOW TO BOOM

Figure 6.25

Figure 6.26

Figure 6.27

HOW TO BOOM

Watch Class 17—"Booming Techniques."

Static and Motion Booming

Once you have the basics down, you need to apply them to a shot. Whether you're moving around chasing dialogue or trying to meld in with the walls for an interview, booming takes hard work and practice.

FIRST THINGS FIRST

Before I move into actually being on set, I want to address your dress!

A location sound operator is often one of the crew members who are closest to the talent during recording. Wearing a bright orange shirt and shiny track pants will quickly have you wearing someone else's threads.

Bright reflective clothes will piss off the camera operator faster than getting the boom in the shot. You want to wear dark colors, black preferred.

Noisy fabrics and squeaky shoes can also lead to embarrassment when everyone quiets down for a shot and you're squeaking and rustling away.

Figure 6.28 Black on black!

Check the volume of your attire!

READY FOR THE SHOT

You're going to run into two kinds of shots: static and motion. Static booming will most likely be an interview, and motion booming will be anything that has you following the camera operator around. Regardless of the style, all proper micing techniques apply, so keeping the mic pointed at the talent's sternum is on the menu.

STATIC SHOTS

For static shots your priority will be comfort. Standing through a 45-minute interview can be excruciating and embarrassing if you start shaking apart. You're going to need a reprise during the ordeal. Since interviews will most likely be the main reason you're hired for a video shoot, it's real important you get comfortable booming without too much moving around. In static shots, staying loose and comfortable without a lot of movement is your top priority.

Figure 6.29

The three booming positions I use will prevent you from cramping up and getting fatigued. The booming positions that only use one hand are perfect if you need to make an adjustment to the mixer. See Figures 6.30, 6.31, and 6.32.

Figure 6.30

Figure 6.31

Figure 6.32

HOW TO BOOM

- When you're readying yourself for a static shot, first choose a booming position (where you'll be standing) that will be the least distracting for talent. Position yourself on the opposite side of the key light to prevent boom shadows (the key light is the brightest light source hitting the talent). If the key is on the right side of the camera, boom from the left side of the camera. By standing away from the bright key light you won't be lit up like a Christmas tree. If you're outdoors, the key light would be the sun.
- When booming a static shot, stand at a 90-degree angle to the talent (the side of your body facing the talent—hopefully this is your thinner width). It's less distracting.
- Use slow, gentle movements when moving between booming positions. It's important during static shots that you're not bouncing around and distracting the talent.
- To prevent cramping up, change booming positions every 30 to 60 seconds without moving your feet or mic position.

Figure 6.33 My perspective

MOTION SHOTS

For motion shots, the gloves are off! Anything that could possibly hinder your booming position will. Boom shadows will play havoc with your mic placement. Being attached to the camera will force you to boom with only one hand and in awkward positions, and camera operators will complain about the control cable pulling on the camera. The sad truth is that you're going to have to finesse all these things to achieve good results, and you'll be the only one who knows how tough it really was to get it.

The final framed shot dictates everything you'll do, and the camera operator in most cases will not assist in making it easier. So don't complain, and carry yourself professionally. Hey, you may even get a "good job" comment.

I actually find motion booming much easier than static booming. Moving my entire body brings smoothness to my arm and hand movements—there's a fluidity to it. Obviously a 6-foot boom pole is much easier to handle then a 12-foot or 16-foot, so try and keep the boom pole as short as possible whenever you can. Getting yourself in the best position to boom from, when the camera is moving all over the place, adds another variable to getting and keeping the mic where it needs to be. Always face the camera operator during motion shots. Have them in the corner of your eye all the time and make sure they can see you as well—be ready to move without notice. Be ninja ready, have cat reflexes, be a superhero!

Now let's add in being attached to the camera. It's a necessary evil that you'll need to address at the beginning of every motion shot. My main concern is that I can operate effectively, efficiently, and not get tangled up—impeding my ability to record the best audio possible.

The amount of control cable—or "length of leash," as I like to call it—will depend on the amount of movement. If there is minimal movement, I won't hesitate to let the control cable hit the ground.

Figure 6.34

If there's a lot of movement, I'll let out about five feet of cable and tuck a portion of it into the back pocket or belt loop of the camera operator to prevent any swinging of the control cable getting to the camera.

Figure 6.35

> *Camera operators are a sensitive bunch so at least show concern for their multitude of complaints about being cabled into! Like we're enjoying it—right!*

Having the proper amount of cable will also prevent you and the camera operator from stepping on it. If you let out too much control cable it will cause nothing but grief, because it'll act like a fishing net. You'll be dragging chairs, tables, and small children around with you before you know it. So pay attention to where it's hanging.

Your last responsibility during motion shots is to look out for and guide the camera operator when necessary. You are his or her second set of eyes when you're moving about. If you walk the camera op off a cliff, you're going too because you're attached. It's in your best interest to guide the op safely during the shot. I use several one-hand booming techniques to accomplish this. It's a real bear moving fluidly, but it is your job.

"Watch Class 18—"Booming Techniques."

One-Hand Booming

One-hand booming is another technique that is quite hard to master, but it's an absolute necessity for video location sound operators. The one-hand booming technique is primarily used in order to free a hand to make adjustments to the mixer and or guide the camera operator during motion shots. It's used in short bursts, due to the strain it puts on your hand and shoulder.

HOW TO BOOM

Figure 6.36

Figure 6.37

Figure 6.38 I use this one a lot!

From the basic booming position you learned earlier in this chapter, it's easy to move into all three positions shown in Figures 6.36, 6.37, and 6.38. By gripping the pole tighter with the hand you're going to boom with and dropping the other, you're booming with one hand. Be prepared for the full weight of the boom pole on your wrist. The boom pole shouldn't drop at all. It should stay the same height.

These one-hand booming techniques are much easier when the boom pole is at shorter lengths (5 to 7 feet)—I wouldn't even think of trying either technique with a 12-foot of pole out there!

HOW TO BOOM

The one-hand booming technique in Figure 6.38 has become my favorite. I find I can last the longest in this position, and it doesn't strain my wrist. I also find I can easily push the boom pole forward, raise and lower, and change the mic angle much easier then the other one-hand techniques. It's also the easiest one-hand technique for guiding the camera operator.

Watch Class 19—"Booming Techniques."

Never Pass Through the Axis!

When booming a motion shot, it's imperative you keep the talent's mouth within the lobe of the microphone's pick-up pattern. For static shots this is easy, but it's a bit of a challenge when booming a walking shot.

For a walking shot, you and the camera operator will most likely be walking backwards. Since your mic is pointing at the talent's sternum (lobeing technique), they can easily move into the axis portion of the mic's pick-up pattern if you're not careful. Having the voice going in-and-out of the axis when using the lobeing technique will change the volume and tone of the dialogue.

I will always err on the side of booming too far in front of the talent—there's not much sound coming from the top of the talent's head or from behind them.

Keep the mic in front of talent and never let them pass under the mic!

Figure 6.39

Booming the Sweet Spot

The sweet spot is a booming position that maximizes ambience cancellation. Each and every location will have an area where the ambience decreases and can even cancel itself out when the mic is placed there. Yes, you heard correctly. As the sounds that make up the ambience bounce around the room, they increase and decrease in volume in different areas around the room. If you position your shotgun mic in the optimal position for the cancellation ports to do their job, the ambience of that room will decrease. That's what I call the sweet spot! This spot could be where you've set up to record or not, but each framing will have a booming position that decreases the ambience—the amount of cancellation may be very slight or very considerable.

I've had locations where I've just about 100 percent canceled out unwanted ambiences just by slightly moving the mic.

If ambience becomes a concern, I'll sometimes move around the room listening for the spot where maximum cancellation occurs. This doesn't mean I start telling the camera operator how to frame a shot because it sounds better at the other end of the room. But if I'm getting killed and there's nothing I can do to prep the location further, I would suggest it.

When I'm booming, I don't just throw the mic above the talent and consider the job done. I move the mic around above the talent's head and listen for changes in the ambience.

Figure 6.40

Figure 6.41

Figure 6.42

Sometimes the changes are subtle and sometimes they are quite drastic. By slowly moving the mic from left to right (always keeping the mic out of the shot) and changing the pitch (moving your back hand up and down), you can choose the best booming position for that location. I listen for changes in the ambience—mostly for it to decrease. Once I've found this position, that's where I boom from. Remember, all micing techniques still apply.

Lighting can also dictate your booming position due to shadows, but you still must apply this procedure and listen closely. There is always a position for every framed shot that is best.

Watch Class 20—"Booming Techniques."

Scooping

Scooping is a booming technique used when there's a lot of ambience coming from below the talent (walking on gravel or snow) or the lighting is causing boom shadows that will be seen in the shot.

HERE'S THE SCOOP

Scooping is positioning your shotgun mic below the frame and pointing the mic up at the talent. See Figure 6.43. Some location operators like to boom interviews this way, because they can crouch down or just dangle their arms. I'm not a fan of this booming style at all. It messes with the cancellation properties of the mic, shoots up the talent's nose and gives a nasally quality to the voice, and puts the mic close to the talent's body, accentuating clothing noise and body movements.

But if the ambience from below becomes a concern or the lighting is making it impossible to get the mic in a decent position without casting boom shadows on the talent, I won't hesitate to flip my mic over and point towards the sky.

If you compare booming from above to scooping, you'll hear what I'm talking about!

Figure 6.43

HOW TO BOOM

Watch Class 21—"Booming Techniques."

Booming Quick List

- Always face the camera operator so you can easily move with him or her.
- If the shot is static, turn your body 90 degrees to the talent. If there's motion, stand 45 degrees to the talent.
- If the shot is static, get comfortable and use the three static booming techniques.
- If the shot has motion, let out five feet of control cable and be ready to follow and guide the camera operator.
- Look for boom shadows. Always boom from opposite the key light. If you're outside, the sun would be the key. If you're getting hooped by shadows, let the camera operator know. They can always move enough to get the shadows to fall in your favor.
- Find the sweet spot on every shot. Put the mic above the talent and move it in an arc listening for changes to the ambience. Make a choice that best suits the shot.
- Match the perspective of the shot. If it's a tight shot, boom close to the mic's minimum range. If it's a medium to wide shot, boom closer to the mic's maximum range. Use your ears.
- Always extend the boom pole from the smallest section first.
- Use a one-hand booming technique to make adjustments while shooting.
- Use the lobeing technique for recording consistent dialogue. Point the axis of the mic's pick-up pattern at the talent's sternum. Never let the talent pass through the axis.
- Most importantly—*relax.*

CHAPTER 7

Lavalier Microphones

The Lavalier
Lavalier Basics
When to Use Lavalier Microphones
Lavalier Design Types
Applying a Lavalier
Exposed Micing Technique
Hidden Micing Techniques
Lavalier Techniques: Micing on the Head
Hiding a Top-Loaded Lavalier

Figure 7.1

The Lavalier

In today's world of location audio for video, the lavalier, or lav, has become a real workhorse. For almost all one-man-band camera operators, lavaliers provide a quick and easy solution for getting usable sound to the camera. For many location sound operators, lavs are a safe and easy solution for capturing dialogue.

Lavalier Basics

We've all seen lavaliers on TV—usually an exposed lav on a news anchor or talk show host. They're used quite extensively and produce quality sound when applied properly.

Lavaliers do a great job of recording intelligible dialogue in noisy locations. They are a close-proximity microphone that can be applied to the head or chest area of the talent. Since they are applied so close to the sound source (the mouth), they do a great job of quelling the surrounding ambience—bringing the dialogue forward and pushing

LAVALIER MICROPHONES

ambience back. When used with a wireless system, they can capture quality sound on locations that would be impossible with a shotgun.

HARD-WIRED LAVALIER

The hard-wired lav is designed for direct cabling into a mixer, camera, or recorder. It comes with a power supply (AA or 1.5V watch-type battery) built into an XLR barrel to power the mic if 48V phantom is not available. See Figures 7.2 and 7.3.

Figure 7.2 Tram TR50, hard-wired with various clips for applying

Figure 7.3 Lavalier power supply with 1.5V watch battery

Hard-wired lavaliers are perfect for the sit-down style of interview. Since they're cabled directly into the camera or recorder, you won't have any RF hits. The disadvantage of a hard-wired lav is the talent pretty much has to be stationary—not much moving around allowed.

WIRELESS LAVALIER

The term *wireless lavalier* is a bit misleading, since there are no lavaliers without wires. It refers to the combination of a wireless system and a lavalier.

To use a lavalier with a wireless system, the lavalier needs to be fitted with the proper connector that the wireless system uses. This is done by a technician at your favorite retailer of all things location audio. See Figures 7.4A, 7.4B, and 7.4C.

LAVALIER MICROPHONES

Figure 7.4A

Figure 7.4B

Figure 7.4C

The only real disadvantage of the wireless lavalier is the chance of RF hits—those nasty snaps and pops that come out of nowhere and ruin a perfectly good dialogue recording. The big advantage is the freedom for the talent to go almost anywhere.

When to Use Lavalier Microphones

I'm a bit of a shotgun snob. I prefer the sound they produce, but lavaliers do have their place. Here are the instances during a shoot when I would use them:

- Booming becomes a distraction.

If the location has an audience, like a speech in a theater, or a lecture in a classroom, any shot where booming will be distracting for the audience, I use a wireless/lavalier combination—even if I can reach the shot with a shotgun mic and be out of the frame.

- The shot is too far away to reach with a shotgun mic.

LAVALIER MICROPHONES

If the talent is impossible to follow, like someone skiing, riding a horse, or a big long-lens walk-and-talk, I'd use a lavalier/wireless combination. Any shot that's impossible to reach without getting my body, the shotgun mic, or the boom pole in the shot.

- The ambience of the location is too loud for a shotgun mic.

Lavaliers are close-proximity microphones with a reach of about 12 inches, so they do a great job of cutting down ambience. If I feel the ambience is too loud for the shotgun mic, I would detach the shotgun and only use the lavalier. If I'm in a location that has an ambience level that is bordering on too loud for a shotgun mic, I'll put a lavalier on the talent but still boom the shot. This covers my butt in editing if the ambience on the shotgun track proves to be too loud. Remember, I'm a bit of a shotgun snob!

I NEVER USE A LAVALIER WHEN IT'S WINDY!

Wind is the one thing that'll wreak havoc on the most beautifully applied lavalier. It only takes the slightest breeze to cause distortion. If the wind picks up when you're using an exposed lav, the supplied wind sock is useless. And depending on the type of clothing and fabric, placement options, and strength of wind, many hidden mic techniques won't work either.

There are small aftermarket windjammer-type windsocks for lavaliers. Personally, I think they look stupid—like the talent has a gerbil curled up on their lapel. But if your only option is an exposed lav, then gerbil it is.

In windy conditions, a shotgun mic in a full Rycote system is often your only option.

Watch Class 22—"Lavalier Microphones."

Figure 7.4D

ENTERING SOMEONE'S PERSONAL SPACE

"Hi, my name is Dean. I'm the sound guy, and I'm going to be putting a mic on you." This is a good way to start the whole uncomfortable process. Putting a lavalier on someone can be pretty nerve-wracking. I've watched seasoned location sound operators fumble through a simple wire job because the talent was intimidating. I've had my share of uncomfortable wire sessions that had me sweating buckets, and you'll have yours! They do come to an end, and the sun will rise again.

Figure 7.5

You're going to be touching someone you may have never met before. You may be touching their shirt, pants, possibly their skin and hair. You're going to be looking right at a woman's chest from a foot away and adjusting her blouse and possibly her bra. For you female operators this is no big deal, but for the men, the studly facade quickly turns into red-faced embarrassment. It's a real invasion of someone's personal space. So how do you put a lavalier on someone without embarrassing either party? How do you make it comfortable for the talent and for you?

In video, working with seasoned professional talent is more the exception then the norm. Most "talent" in the world of documentary, corporate, and lower-budget drama are not familiar with the lavalier micing process. I've wired hundreds of men, woman, and children, and I have learned a few tricks that really take the uncomfortable weirdness out of the whole lavalier micing experience. This is what I do.

LAVALIER MICROPHONES

Figure 7.6

- Check your breath! There's nothing worse than stinky breath. I carry Listerine packets in my wiring kit to assure I don't melt the talent.
- Introduce yourself with a friendly smile and gentle tone in your voice. Don't scare the hell out of them with a commanding lieutenant bark! Be friendly and calm. See Figure 7.7.
- Be sure to make eye contact while you're talking. Even though you'll be touching the person's shirt or blouse, don't approach them staring at their chest. Man or woman, it's rude!
- Don't bring your mixer, boom pole, lav, or wireless system on your first introduction. Some people find the equipment unnerving.
- Explain what you're going to do before you start checking the clothing for mic placement. For example, "*I'm going to be placing a small mic and transmitter on you so I can record what you're saying.*" See Figure 7.8.

Figure 7.7

Figure 7.8

- As you examine the talent for mic placement, explain where and how you're going to be attaching the mic. Make contact with the areas of the body you'll be contacting during the actual micing. This gives the talent warning regarding the area(s) you'll be working. I always use my thumb when I make contact during the explanation, never my fingers. The thumb is a very harmless digit compared to your pointer finger, and I always look them in the eyes during the explanation. See Figure 7.9.

Figure 7.9

- Placing your hand on the shoulder of younger talent is a disarming, comforting contact. Children and young teens are the most uncomfortable with body micing—as well as the teenage girl's mother who is hovering the whole time you're working.
- When you start micing the talent, relax, be efficient, and be professional. There will be time for joking, but it's not when you have your hand in someone's shirt!

Figure 7.10

LAVALIER MICROPHONES

It should take no more then 45 seconds to complete most micing techniques.

- After the mic is on, take a few seconds to look at the talent's wardrobe and straighten out anything you have possibly messed up.
- If you're micing professional talent, most of the steps for making them comfortable with the micing process become irrelevant. Professional actors and actresses are used to being miced. The best thing you can do is be efficient and professional.

TIP! Think of what your doctor does to make you comfortable during an examination. Hand on your shoulder, eye contact, an explanation of what he or she is going to do, and then they go about their job efficiently and professionally. There's no laughing while they're working, no shaking or heavy breathing. Imagine if your doctor started giggling while examining you! I use these bedside manners to help put the talent at ease.

Watch Class 23—"Lavalier Microphones."

Lavalier Design Types

Before we start applying lavaliers, there are a couple of different types of lavalier microphone to look at.

The most commonly used types of lavaliers are the front-loaded lav (see Figure 7.11A) and the top-loaded lav (see Figure 7.11B).

Figure 7.11A Tram TR50

LAVALIER MICROPHONES

The Tram TR50 is one of the most commonly used front-loaded lavaliers. *Front-loaded* refers to the way the capsule lays flat on the front of the mic. When applied to the body, the capsule faces forward and lays flat to the body. I like using this type of lavalier when body micing.

Figure 7.11B Sanken COS-11D

The Sanken COS-11D is a very popular top-loaded lavalier. The capsule is positioned on the top of the mic head. When placed on the lapel, this type is perfect for exposed news-style micing. Because the mic capsule points up to the source (the mouth), the mic has a lot of gain—I also find this design helps decrease tone changes when exposed on the lapel.

There's been a glut of new lavaliers hitting the market lately. Some as cheap as $50! Some manufacturers copy the more commonly used designs, others try to bring something new and potentially industry changing. Most come with an assortment of clips for applying the mic.

A little warning, if the wireless system includes a lavalier in the kit, it's probably not very good. I'd strongly recommend replacing it with an aftermarket lavalier.

Applying a Lavalier

In this section, on applying lavaliers on talent, I'll be using both front- and top-loaded mics, various adhesive tapes, and the clips supplied by the manufacturers when the lavaliers were purchased. Here are a few tried and true techniques I use for the lion's share of lavalier work I do.

LAVALIER MICROPHONES

The techniques used by professionals are as varied as the operators applying them. There are a few no-nos that you must avoid, but if the voice is clear and the clothing noise is quelled, you're on the right track.

The most common area to apply a lavalier microphone is on the chest area of the talent's body. Lavaliers can be exposed, like what you see on a newscast, or hidden, like . . . well, you can't see them . . . but they're there!

Figure 7.12A

Figure 7.12B

When placing a mic on the body, you want to try and keep it as close to the center of the body as possible, at approximately the height of the sternum. By keeping the mic closer to the center of the body, the lavalier will produce more consistent tone and volume when the talent moves his or her head from left to right. By placing the mic at sternum level, it gives the recording a looser feel (which is more real sounding), with the added bonus of being low enough that it won't be seen on a close-up when the mic is exposed.

When placing a lavalier mic on the talent's body, you're going to have to deal with clothing noise even when the mic is exposed. Noisy fabric can ruin a good recording. Silk, nylon, and Gortex are a few fabrics that will cause nothing but grief. So, if you see these fabrics, body micing will not be an option.

If by looking at the talent's clothing you feel there could be a potential problem, quickly clip-on an exposed lav and ask the talent to move around. You'll hear whether the clothing noise is too loud. Don't waste the production's time doing a fabulous micing job if the wardrobe will be rendering the lavalier unusable.

Experience with body micing is really the only way to get good at it. Be smart, consider the various micing options, take your time, and learn from every job.

Exposed Micing Technique

The exposed lavalier technique is most commonly found on newscasts, talk shows, and shows with panels of guests—any show where you'd expect to see a microphone clipped to the tie or lapel of talent.

Exposing the lav will produce the highest quality sound these little mics offer. If the sound entering the mic is not being muffled in any way, lavaliers can actually sound quite good. The down side to exposed lavs is you can see them, so for drama, exposed techniques are rarely used.

When you expose a lavalier you must use the wind sock! I know it can be a little unsightly, but lavaliers have no wind protection at all and it takes a very small puff of air to distort the diaphragm of the mic. If you think you can go without the wind sock indoors, think again. It'll take only one actor who's a nose breather to change your mind.

When exposing a lavalier on the talent's wardrobe, it should be nicely placed and symmetrical. Take a look at what they're wearing. Placing the mic on a darker part of the fabric, a button hole, or even following the cut or lines in the fabric can make the lav less distracting.

The wind sock should be clean, not dented or crushed. Clips should be in perfect condition, the cable clean and not full of kinks. Remember, the mic is going to be seen on camera—don't embarrass yourself with a nasty, worn-out lav.

Pet peeve! It drives me crazy when I'm watching a show and during the close-ups, there it is, bouncing along the bottom of my TV screen—the wind sock of the lavalier. Keep the lav at sternum level, just out of the close-up.

NEWS STYLE: TIE CLIP

I use the news-style micing technique just about every time I expose a mic on the chest area of talent. It can be used on ties, button shirts, and zipper or button jackets.

LAVALIER MICROPHONES

1. Choose the tie clip from the case. See Figure 7.13.

Figure 7.13

2. Place the mic in the clip. If you're using a front-loaded lav, place it in the clip with the capsule facing out. If you're using a top-loaded mic, point the mic upwards. See Figure 7.14.

Figure 7.14

LAVALIER MICROPHONES

3. Put the wind sock on. See Figure 7.15.

Figure 7.15

4. Feed the cable through the clip. You'll have to squeeze the clip to open the jaws. Make a one-inch loop with the cable under the clip. It's important to have a nice symmetrical loop. Not too big, and not too small. See Figure 7.16.

Figure 7.16

5. Unzip or unbutton the talent's shirt in the area you are attaching the tie clip so you can work more efficiently. This doesn't mean you unbutton the whole shirt or blouse. One or two buttons will suffice. With a coat or jacket, open it up all the way if it's appropriate.

LAVALIER MICROPHONES

6. Feed the excess cable through the talents clothing and out the bottom of the jacket or shirt. Never leave the cable exposed down the front of the clothing. See Figure 7.17.

Figure 7.17

7. Attach the clip with the cable still in the jaws at approximately bottom sternum height and as close to the center of the body if possible.
8. Snug the clip to the edge of the shirt, tie, jacket—whatever the clothing you are micing. See Figure 7.18.

Figure 7.18

9. Flip the tie or clothing flap back and make a second loop by running the cable back through the jaws of the clip. Have the jaws grip the cable. Some clips will have an added clip to secure the loop. This loop and extra clip act as a strain relief to prevent damaging the mic from a sudden tug. See Figure 7.19.

10. Button up the shirt or blouse and make adjustments to the visual appearance of the mic and clothing. The mic should be straight with a symmetrical loop, and the clothing should look like you were never there. This final clothing and mic adjustment is important. Take time to step back and make sure it looks good. See Figure 7.20A.

Figure 7.19

Figure 7.20A

This is what the mic in the clip looks like when not applied to the clothing. See Figure 7.20B.

LAVALIER MICROPHONES

Figure 7.20B

11. Connect the lavalier to your system.
 - If you're using a hard-wired lavalier, clip the power supply to the talent's belt, top edge of pants or skirt, or back pocket. Run the cable (still under the clothes) around the talent's body. Coil up the excess cable (make sure to leave slack for movement) and tuck it into the top of the talent's pants or skirt. Connect a 25-foot XLR cable to the lavalier's power supply, and attach that to your mixer.
 - If you're using a wireless system, the most common place to attach the transmitter is the top edge of the talent's pants or skirt at the small of his or her back. The transmitter will have a clip to make it easy. Run the cable (still under the clothes) around the talent's body. Coil up the excess cable (make sure to leave slack for movement) and tuck it into the top of the talent's pants or skirt. Do not cross the transmitter's antenna with the cable from the lavalier. See Figure 7.21. Also check out Chapter 8, "Wireless Systems," for more information on RF signal and transmitter calibration to ensure correct operation.

Figure 7.21

142

- To help hide the wireless transmitter and prevent it from bouncing around the talent's waist, it's good practice to spin the transmitter around and place the entire pack in the talent's pants or skirt. See Figure 7.22.

Figure 7.22

Watch Class 24—"Applying a Lavalier (Exposed)."

Hidden Micing Techniques

If you've ever tried to hide a lavalier microphone on talent, you've probably realized it's a lot harder then you thought. Making it sound clear, getting rid of the clothing noise, and hiding it so the camera won't see it—there's a lot to get right. Hidden mic techniques are what most operators are constantly looking for.

Mics in beards, hollowed out pens, even behind mirrored sunglasses—you'd be surprised at where the mic is sometimes hidden. I've experimented with a plethora of tapes and adhesives, built little cages and wind socks, even cannibalized clips trying to improve my chances for clean sound. The gloves really are off when it comes to hiding lavalier microphones.

Even though I've experimented and learned many micing techniques, I find that I use the following three techniques most often when hiding mics on the body.

LAVALIER MICROPHONES

BUTTON SHIRTS: VAMPIRE CLIP

Between the buttons on a dress shirt or blouse is a perfect place to hide a lavalier. The mic is centered on the body, and the layered fabric hides and isolates the mic.

1. Choose the vampire clip from the case. See Figure 7.23.

Figure 7.23

2. Place the mic in the vampire clip with the capsule facing towards the clip. See Figure 7.24. This will prevent clothing from touching the screen of the mic when it's hidden.

Figure 7.24

LAVALIER MICROPHONES

3. Make a loop in the cable and secure it with a small piece of tape. See Figure 7.25. The first one to two inches of the lavalier's cable closest to the head of the mic is very sensitive and will transmit noise to the microphone easily. This loop will dull the cable down as well as act as a strain relief.
4. Unzip or unbutton the talent's shirt in the area you're attaching the vampire clip so you can work more efficiently. This doesn't mean you unbutton the whole shirt or blouse. One or two buttons will suffice.
5. Feed the excess cable through the talent's clothing and out the bottom of the jacket or shirt. See Figure 7.26.

Figure 7.25

Figure 7.26

6. Place a one-inch piece of white camera tape on the underside of the section of shirt to which you are attaching the vampire clip. This will give rigidity to flimsy material as well as prevent the pins of the vampire clip from damaging the talent's clothing. See Figure 7.27.

Figure 7.27

145

LAVALIER MICROPHONES

7. Place the clip half way between two buttons. If you place the lavalier close to a button the friction at the buttons will create noise. Be careful not to stab the talent with the pins of the vampire clip. Hold the fabric away from the talent's skin when pinning. See Figure 7.28.
8. Tuck the loop behind the shirt. See Figure 7.29.
9. Button up the shirt or blouse and make one last adjustment to the visual appearance of the clothing. It should look like you were never there. This final adjustment is very important. Take time to step back and make sure it looks good. See Figures 7.30 and 7.31.

Figure 7.28

Figure 7.29

Figure 7.30

Figure 7.31

LAVALIER MICROPHONES

10. Connect the lavalier to your system. See the earlier section, News Style: Tie Clip, Step 11, for how to connect.

POROUS FABRIC: MOLESKIN

One of the ugliest micing techniques I see is the tie clip or vampire clip on the neckline of a T-shirt, sweater, or hoodie—very amateur! I understand why this occurs: the mic is slapped on for a quick interview and the operator either doesn't know how to hide a lav, there's no time, or the talent thinks he or she knows how to do it and does it, or the talent doesn't want to be body miced. Well here's the fix—moleskin!

1. Purchase a box of Dr. Scholl's Moleskin at the pharmacy. Buy the large box that has a five-by-seven-inch solid full sheet. You'll go through it like milk. See Figure 7.32.

Figure 7.32

2. With a pair of sharp scissors (very sharp, or you'll be hacking at it for a while), cut a 2-inch by 1.5-inch rectangle piece. Round off the corners. I always carry ten precut pieces for speed. See Figure 7.33.

Figure 7.33

3. Remove the paper backing from the moleskin to expose the gluey surface.
4. Lay the head of a front-loaded lavalier (I use my Trams here) into the gluey surface, capsule out. See Figure 7.34. Don't stick the capsule into the glue!

Figure 7.34

5. With your fingers, pinch the moleskin to the sides of the mic head creating a pocket that the lavalier will sit in. Then gently grab the edges of the moleskin with your thumb and second finger and squeeze together so the front of the mic is level with the edges of the moleskin. This prevents the mic from creating a bump in the fabric as well as making it easier to apply. See Figure 7.35.

Figure 7.35

6. Untuck the clothing you are attaching the mic too for easy excess. With the mic in one hand, pull the clothing forward with your other hand and slide the moleskin and mic up under the shirt to the height of the talent's sternum. Attach the moleskin to the shirt by pushing your index finger forward and gently releasing the edges of the moleskin from your thumb and second finger. You want the mic to be flush with the edges of the moleskin. Do not push too hard, or you'll create an unsightly mic outline on the shirt. See Figure 7.36.

LAVALIER MICROPHONES

Figure 7.36

Figure 7.37

7. The shirt itself will act as a windsock. Be careful with iron-on logos and decals. Heavy vinyl or plastic iron-on designs won't let sound pass through.

8. Figure 7.38 shows how the mic looks inside the T-shirt. Notice how the mic is completely surrounded by the moleskin, and the capsule is recessed into the moleskin and not pushing out onto the fabric.

Figure 7.38

9. Connect the lavalier to your system. See the earlier section, News Style: Tie Clip, Step 11, for how to connect.

SKIN AND CHEST AREA: LEATHER CLIP

Micing on the skin is most successful on people with no chest hair. So all "monkey men" are out unless they're prepared to tango with a razor. Men with little or no chest hair and women are the best candidates.

Men with muscular chests (with no chest hair) and all women have the perfect place for body micing. With the mic placed at the sternum there is no chance of the clothing coming in contact with the mic, making the cleavage area the best place for body micing on the skin.

If I have to hide a lavalier on a woman wearing a blouse, T-shirt, or sweater (as long as the clothing is not too dense), the leather clip is always my first choice. It sounds great and clothing noise is nonexistent.

1. Choose the leather clip from the case. See Figure 7.39.

Figure 7.39

2. Cut a piece of double-sided tape and stick it to the rough side of the leather clip, big enough to completely cover the leather. Do not remove the wax paper from the second side of the tape just yet. See Figure 7.40A.

LAVALIER MICROPHONES

Figure 7.40A

3. If you are micing a man, expose the sternum area by unbuttoning his shirt or lifting his sweater or T-shirt. See Figure 7.40B. Go to Step 7.
4. If you're micing a woman wearing a button shirt or blouse, unbutton it in the area you are attaching the leather clip. This does not mean you unbutton the whole shirt or blouse. One or two buttons will suffice. You'll need to expose the area you're working in.
5. Drop the connector end down her shirt between her breasts, under her bra, and pull the excess cable out the bottom of the shirt or blouse. You *must* have the cable under the bra! If you don't, when the talent moves or takes a deep breath, the bra will pop the mic out of the clip. If the talent is nervous about you being inside her clothes, have her thread the mic through herself. See Figure 7.41.

Figure 7.40B

Figure 7.41

LAVALIER MICROPHONES

6. With a sweater or T-shirt, have talent raise the clothing only in the middle to expose her sternum. Some women are sensitive about their tummies, so you'll have to get them to chill on this so you can attach the mic properly. Pulling the collar of a T-shirt down can badly stretch it.

7. For both men and women, with the skin exposed that you're going to work on, attach a one-inch piece of hypoallergenic skin tape on the talent at the center of his or her sternum. This is where you're going to secure the leather clip. Hypoallergenic skin tape will prevent any possible skin irritation that double-sided tape can cause, and it stays put if the talent sweats. See Figure 7.42.

Figure 7.42

8. Place the lavalier in the leather clip with the capsule facing *toward* the leather clip. You want the capsule of the mic to be facing the body. This will prevent clothing from touching the screen of the mic when it is hidden. See Figure 7.43.

Figure 7.43

9. Remove the wax paper from the double-sided tape on the back of the leather clip and secure the mic to the skin tape. See Figure 7.44.

Figure 7.44

10. Button up the shirt or blouse and make one last adjustment to the visual appearance of the clothing. It should look like you were never there. This final adjustment is very important. Take the time to step back and make sure it looks good. See Figure 7.45A.

Figure 7.45A

Connect the lavalier to your system. See the earlier section, News Style: Tie Clip, Step 11, for how to connect.

Lavalier Techniques: Micing on the Head

Placing the lavalier mic on the talent's head is a great option if his or her clothing is too noisy, or there's a lot of physical action. I've had great success micing skiers, elaborate costumes, fight scenes, and bikini-clad girls (we didn't see their backs) by moving the micing technique up to the head. Personally, I think lavaliers sound better up on the head than they do on the body. Micing on the head negates volume surges from the talent talking down, as well as tone and volume changes when the talent's head turns left or right.

LAVALIER MICROPHONES

Figure 7.45B

> *Location audio operators must know how to use lavaliers, especially if you want to do drama-style shooting.*

When placing a mic on the talent's head, hiding the cable can sometimes become the biggest problem. If talent is moving around and the camera is going to see the back of the talent's head, you're going to need to hide the cable as it goes down the neck. Long hair, a high-collar shirt, and make-up will all help conceal the cable. If you can't be absolutely certain the mic and cable will be hidden, I suggest you move down to the body. If it's a straight-on shot, a small piece of skin tape will do to keep the cable from accidentally moving out from behind the neck.

HATS AND BASEBALL CAPS: CAMERA TAPE OR MOLESKIN

When hiding a lavalier in a hat you can use either a front-loaded or top-loaded lavalier. Here are the techniques I use.

For years I used a Tram TR50 front-loaded lav when micing a baseball cap. I started using a Sanken COS-11D top-loaded lav for this application and prefer the results.

HIDING A TOP-LOADED LAVALIER

1. Cut two pieces of moleskin, 1-inch by 1/2-inch, and place the lav in one piece. See Figure 7.46.

Figure 7.46

LAVALIER MICROPHONES

2. Tape the lav to the inside edge of the hat with the capsule facing down, just barely sticking out. I like to position the mic where the talent's hair starts at their temple. See Figure 7.47.

Figure 7.47

3. Put an extra cable inside the hat and tape it down to the back of the cap to prevent the cable from accidentally moving to the side of the head.
4. Place the hat back on the talent with the cable hanging down the back. See Figure 7.48.

Figure 7.48

5. Run the cable down the talent's back inside his or her clothing.
6. Have talent tip slightly forward with the head and secure the cable to the neck with skin tape. See Figure 7.49.

Figure 7.49

7. Unless the camera is on an extreme close-up and shooting up the talent's nose, the camera should never see this micing technique. See Figure 7.50.

Figure 7.50

Connect the lavalier to your system. See the earlier section, News Style: Tie Clip, Step 11, for how to connect.

WIND SOCK EXTRAORDINAIRE

Even though the lav is visible to the naked eye, the chances of the camera picking it up are very remote. Also, with the mic tucked in tight to a person's head, the mic is less susceptible to wind noise. Experiment with this micing technique in the wind—you'll be surprised how much the hat and head become a wind sock.

GLASSES: DOUBLE-SIDED TAPE

Hiding a mic in a pair of glasses is quite simple, and if they're sunglasses the camera will never see it. The glasses do need to have fairly wide arms for attaching and concealing, but even if the mic is a little wider than the arm, nobody will notice.

1. Clean the arm of the glasses with rubbing alcohol about half an inch from the lens. This is where you'll be concealing the lav. See Figure 7.51.

LAVALIER MICROPHONES

Figure 7.51

2. Cut a small piece of two-sided tape (clear is best), and stick it to the back of the lavalier microphone. See Figure 7.52.
3. Remove the paper from the second side to expose the tape and attach the mic to the arm of the glasses. See Figure 7.53.

Figure 7.52

Figure 7.53

LAVALIER MICROPHONES

4. With a small piece of tape, secure the cable to the arm of the glasses where the arm bends around the ear. See Figure 7.54.

Figure 7.54

5. Place the glasses on the talent. See Figure 7.55.

Figure 7.55

6. Have the talent tip his or her head forward, and secure the cable to the back of the neck with skin tape. Make sure there is slack so moving the head isn't a problem.

Figure 7.56 You can't even see the mic.

7. Run the cable down the talent's back on the inside of the clothing and connect the lavalier to your system. See the earlier section, News Style: Tie Clip, Step 11, for how to connect.

Watch Class 25—"Applying a Lavalier (Hidden)."

CHAPTER 8

Wireless Systems

Wireless Introduction
Wireless Basics
Setting Up a Wireless System
Calibrating the Receiver to a Field Mixer
Calibrating the Receiver to a Video Camera
Wireless Hop

Wireless Introduction

If there's one area in the location audio world that has evolved the most, it's the wireless system. Every time I step into my favorite dealer of all things location audio, there's a new wireless system in the showcase. New brands boast amazing stability, and old ones are new and improved. It's like buying laundry detergent!

Advances in technology have put wireless systems in the hands of, well, everybody. The price point has dropped dramatically, while the performance, features, and ease of operation have improved so much that you don't need an engineering degree to get them to work properly.

I remember my first forays with wires in the late 1980s, and immediately I start hyperventilating! They weren't plug-and-play by any means.

In today's shooting, knowing how to calibrate a wireless system to the variety of cameras, recorders, and mixers is an absolute must.

WIRELESS SYSTEMS

Figure 8.1

Figure 8.2

My biggest beef about wireless systems are those nasty static snaps that ruin perfectly good takes. The "RF hit" or "drop-out" will rear its ugly head at the most inappropriate time, creating nothing but frustration on set. If you intend on using wireless systems as your main micing source, I suggest you buy a diversity system or high-quality non-diversity system. Diversity systems use two antennas to improve the RF reception and minimize drop-outs—and they have a high price tag to go with them. A high-end non-diversity system only uses one antenna but is way more stable than an entry-level non-diversity wireless system. If you try and go inexpensive here, you'll be plagued by RF hits until the cows come home!

WIRELESS SYSTEMS

Figure 8.3A Shure UR5 diversity receiver

Figure 8.3B Sennheiser G2 non-diversity wireless system

Wireless systems do have their place and are necessary: when you can't get a shotgun mic close enough without it entering the frame, or the talent may be too far away, or the camera framing is too wide. It's not very often in video that shots get feature-film big, but you will run into difficulties with certain types of scenarios—a long-lens walk-and-talk for example.

If you're working in big-budget feature film, chances are you probably own multiple systems already. If you're having problems with interference, my answer would be to throw money at the problem and upgrade your system.

For the rest of us in the documentary, corporate, news, and low-budget drama worlds, we just have to do our best with what we can afford and get the most out of it.

Wireless Basics

A wireless system has two components: the transmitter and the receiver. Both need to be properly set and calibrated to achieve optimal performance.

The transmitter (the pack that you place on the talent and plug the lavalier mic into) needs to be adjusted every time you place it on new talent. The receiver (the pack that attaches to your mixer or the camera) needs to be set up and calibrated every time you change the mixer or camera that it's attached to.

WIRELESS SYSTEMS

Figure 8.4 Wireless systems secured in mixer bag

TIP! It's good to have a system set up and cabled into your mixer before you show up on set.

RF SIGNAL

Wireless systems use RF (radio frequencies) to transmit the audio signal from the body-pack transmitter to the receiver. And just like the radio in your car, if you get too far from the transmitting tower or you have objects between you and the tower, you get interference. To let you know if the RF signal is being compromised or getting weak, your wireless system will have an "RF" meter on the receiver (see your manual). It's important that you pay close attention to this meter when you're preparing to shoot. It's informing you if the RF signal is being compromised in any way. If the RF signal is low or is fluctuating, you'll need to remedy this before you start shooting. If you don't, you're going to get burned.

WIRELESS SYSTEMS

Figure 8.5 RF meter on a wireless receiver showing a strong signal

A few tips that will help stabilize the RF signal and decrease RF hits:

- Never cross the transmitter's antenna with the cable from the lavalier microphone. This can reduce the range and stability of your system. See Figure 8.6.

- Keep the transmitter's antenna off the talent's skin. Moisture from a sweating actor or actress can cause hits if the antenna gets damp. See Figure 8.6.

- Never bend either the receiver or transmitter antenna. Keep them straight and free from bumping and jostling wherever possible. See Figure 8.6.

- A wireless system is more stable at close range, so the closer the receiver is to the talent wearing the transmitter, the more stable the RF signal will be. If your mixing position is causing RF problems, use an XLR cable to move the receiver closer to the talent for better reception. Look at the RF meter on the receiver to choose its best placement. See Figure 8.7.

Figure 8.6

Figure 8.7 Transmitter extended closer to talent with a 15-foot XLR cable

164

WIRELESS SYSTEMS

- A clear line of sight between the transmitter and the receiver will increase the system's distance, so the fewer walls, cars, people, and articles of clothing you have between you and the talent, the further away you can be.
- Whenever possible, have the transmitter's antenna exposed. If you will not be seeing the talent's back, place the transmitter on the outside of the clothing.
- Always use fresh batteries. As the battery life decreases in your system, so does the system's range and stability. I replace batteries that are below 75 percent of their full charge in a wireless system.

Figure 8.8 Wireless receiver strapped onto a shoulder harness for better reception

- If the receiver is strapped into my mixer's carrying case, sometimes just moving my body or the receiver's antenna can help reception. I call it "the RF dance" because of the funny positions I find myself in trying to increase the RF signal strength.

Figure 8.9 Replace batteries often in your wireless systems

Watch Class 26—"Wireless System Basics."

Setting Up a Wireless System

If there's one piece of gear I check before every shoot day, it's my wireless system.

Putting in fresh batteries, making sure the lavalier cables and connectors are silent, and checking the performance of the complete system are daily chores.

CALIBRATING THE TRANSMITTER

For setting the proper input level, most transmitters will have an AF input meter and AF peak LED to help you set the proper input volume. The AF or input meter

165

WIRELESS SYSTEMS

shows you how much signal is entering the transmitter, and will help you make sure you don't set the input level too low. The AF peak LED will light up if you have increased the input level too much and are in danger of distorting the transmitter. The AF peak LED should flash during the loudest signal when the talent is speaking. If the AF peak LED is on constantly, then you have set the input level too high and need to back it off a bit.

Figure 8.10 AF meter and AF peak LED on transmitter

Figure 8.11 Adjusting the wireless transmitter's input with talent speaking at performance level

To calibrate a transmitter, simply place a lavalier on the person who'll be performing, have him or her speak at performance level, and either increase or decrease the amount of signal entering the transmitter with the input level control. Some transmitters will have a rotary dial for adjusting the input level, and others will have the adjustment in their menu—consult the owner's manual. If you keep it this simple, you won't go wrong.

Don't rush through this setup. Even though it's easy, take a good 30 seconds and make sure the talent is giving you performance voice levels.

Calibrate the transmitter as follows:

- Place a lavalier on the talent using one of the lavalier techniques described in Chapter 7.

WIRELESS SYSTEMS

- Plug the lavalier into the transmitter.
- Have talent speak at performance level, and adjust the input level control so the AF input meter is indicating between three-quarter and full. The AF peak LED should flash only during the loudest part of the performance. A good strong level into the transmitter means a good strong level entering the wireless receiver. This is the optimal gain structure for a wireless system.

Some entry-level transmitters are only equipped with an AF peak LED and no AF input meter. If your transmitter is set up like this, you'll have to look on your receiver for the AF input meter to calibrate the transmitter more accurately. This meter on the receiver may also be called "Modulation."

Watch Class 27—"Wireless System (Transmitter)."

THE WIRELESS RECEIVER

Wireless systems today are designed for use with consumer cameras, prosumer cameras, and professional video cameras, as well as location audio field mixers and field recorders. The receiver will most likely have the ability to connect and calibrate to consumer and professional line level products and mic level products, and will have a variety of output settings in between for the odd duck gear out there. So selecting the wireless receiver's correct output for your setup can be a bit of a challenge.

Figure 8.12 Wireless Receiver built into the camera

Figure 8.13 Wireless receiver mounted on a DSLR camera

WIRELESS SYSTEMS

Wireless systems are arriving on the market every day, targeting the one-man-band camera operator as the buyer. Many of the entry-level systems designed for camcorders and prosumer cameras come with all the accessories needed for quick hook-up, and they have default settings that make calibrating a snap. They're nearly plug-and-play. Many of the new professional cameras have the option of a built-in wireless system receiver that requires no calibration at all, as the calibration is done in the factory.

With systems becoming easier to calibrate, I still strongly recommend you do a system check to assure proper calibration. If the system is slightly out, your recordings could be compromised.

Calibrating the Receiver to a Field Mixer

You should always calibrate all receivers to your mixer before showing up to a shoot. Don't try to figure this out during production time.

Figure 8.14 Make sure you have the proper cables for the job. Don't use adaptors to jerry-rig a connection.

MIXER SETUP

1. Set up the mixer using the "Initial Setup Procedure for a Field Mixer" found in Chapter 3: CH3 and CH4 are preset to receive a wireless system input.
2. Turn channel fader 3 to about 1:30 or at the midpoint within the channel's unity range. Set the PAD to "0," or if your mixer uses a gain control, adjust the gain to it's unity level, around 12 o'clock.

WIRELESS SYSTEMS

3. Make sure Input 3 is set to "Dynamic," "Mic" level input, and "48V Phantom" is off.

TRANSMITTER SETUP

4. Place the transmitter and lavalier on yourself and calibrate it for correct operation. See "Calibrating the Transmitter" earlier in this chapter.

RECEIVER SETUP

5. Plug the receiver into XLR Input 3 on the mixer and power up the mixer, wireless transmitter, and wireless receiver.

6. While speaking at the level you calibrated the transmitter to, watch the meters on the mixer. You want your meters to be bouncing within the unity range. If they are, the receiver is calibrated to the mixer.

7. If the meters on your mixer are indicating outside the proper unity range—either too low (meters are barely moving) or too high (meters are being pinned)—you need to adjust the receiver's output level.

Figure 8.15

Figure 8.16 Meter's indication within unity range

169

WIRELESS SYSTEMS

- *Do not* insert a PAD on the mixer to decrease the input signal from the wireless receiver. Make sure you adjust the receiver's output to match the mixer. Even though a PAD will lower the signal as it enters the mixer and have you operating at unity, your gain structure is being compromised.

- *Do not* increase or decrease the Channel 3 gain or fader on the mixer to bring the meters into unity. You're calibrating the wireless receiver to the mixer, not the mixer to the wireless receiver.

8. Due to the variety of systems on the market, the label given to the function for adjusting the receiver's output level varies. Some will have it as a rotary dial on the receiver's case, but for many receivers, look in the menu of the receiver for terms like "Output Level," "AF Out," or "Output Volume." If you're not sure where this function lives on the receiver, look in the manual. There are systems that have this switch in the battery compartment.

Figure 8.17 Output adjustment in menu of wireless system

WIRELESS SYSTEMS

Figure 8.18 Meters indicating too low

- If the wireless system has a "Mic" setting for the receiver's output level, set it to that, and the receiver is calibrated.
- If the wireless system has a rotary dial or a bunch of number settings for the receiver's output level (–10, +20, 0, –24), you need to do a little experimenting to set it correctly.

TIP! If you run into talent with a lot of voice sibilance, insert a –10dB PAD on the mixer. Make up the 10dB loss by increasing the output of the receiver by 10dB. The PAD can help quell the highs and those nasty Ssss's. Don't forget to recalibrate after you're done.

9. Once you've located the receiver's output adjustment, you want to increase or decrease the level of output the receiver is sending to the mixer to bring the mixer's meters within their unity range. By setting the mixer's channel fader 3 at 1:30 when calibrating the receiver, you've given yourself room to adjust the volume from the wireless up or down without leaving the proper unity range of the mixer's channel fader.

Once you've calibrated the receiver to the mixer, you won't have to adjust the receiver's functions again unless you plug the wireless system into another mixer or camera. Any adjustments required for proper use of the wireless system will be done on the wireless system's transmitter and/or the location audio field mixer. The receiver is done!

Calibrating the Receiver to a Video Camera

Not that long ago, calibrating a wireless receiver to a video camera was pretty straightforward. The manufacturers, believe it or not, were kinda on the same page. But in the last few years, with DSLRs hitting the market and the race to be first on the block to cater to these photo/video neophytes, all kinds of calibration issues have appeared.

I'm going to keep this very simple and focus entirely on the video camera, because setting up a video camera to receive a signal from a wireless system does not vary much from camera to camera.

When you add DSLRs to the mix with no metering, 1/8-inch input jack, and no headphone jack for monitoring, it becomes a guess-fest with way too many factors for me to lay out an accurate calibration procedure.

So, for calibrating the receiver to a video camera, the basic functions of input and audio select are your only concern.

Figure 8.19

Camera Setup

1. Plug the receiver into XLR jack Input 1.
2. Set the input mode of Input 1 on the camera to "Mic."
3. Set the input select of Input 1 to "Manual."
4. Set Input 1 volume control to "50 percent."
5. Set the monitor select to "CH1."
6. Plug your headphones into the camera's stereo mini headphone jack.
7. Adjust the headphone monitor volume to about "50 percent."

TRANSMITTER SETUP

8. Place the transmitter and lavalier on yourself, and calibrate it for correct operation. See "Calibrating the Transmitter" earlier in this chapter.

Figure 8.20

RECEIVER SETUP

9. The easiest way to calibrate the receiver to a video camera is first to look in the wireless system's manual for the receiver's output level. Under this function's settings, you are looking for "Mic" level. If the wireless system has a "Mic" setting for the receiver's output level, set it to that, and the receiver is calibrated to the camera.

 - If the wireless system has a rotary dial or a bunch of number settings for the receiver's output level (–10, +20, 0, –24), you need to do a little experimenting to set it correctly.

10. Increase the receiver's output level until the meters on the camera are peaking around –6dB. Remember, you're calibrating the receiver to the camera, so don't increase or decrease the camera's input volume.
11. Once you've calibrated the receiver, switch the "Input Select" on the camera to "Auto" to guarantee that the proper level of signal will be recorded.
12. Monitor the signal with your headphones to assure there is no distortion.

Okay, you're probably wondering why I calibrate the camera in "Manual" and then switch to "Auto."

WIRELESS SYSTEMS

This setup is for the one-person camera crew who may not have the ability to make adjustments to the input level on the camera during recording.

By first calibrating the receiver with the AGC (automatic gain control) on the camera in "Manual," I'm getting as close to proper gain structure as possible without a tone oscillator. This will improve my signal-to-noise ratio.

When switched to "Auto" the camera will automatically make minor adjustments to the incoming signal to ensure a strong audio level without going over 0dB and creating distortion.

Watch Class 28—"Wireless System (Receiver)."

Wireless Hop

"Wireless hop" is the funky name given for using a wireless system to transmit the audio signal from your mixer to a video camera. It's an excellent way to get the sound from your mixer to the camera without cables.

Figure 8.21

The ability to move independently of the camera operator makes booming in the field a whole lot easier. No more cables getting in the way, no more wrapping and unwrapping the control cable, and best of all, no more whining from the camera operators. Not being attached to the camera is like getting out from under the oppressor or getting rid of an annoying acquaintance. Yes, it's that good!

I've been going wireless for about five years. The stability and reliability of the systems on the market today have given me the confidence to start using wireless systems to transmit signals from mixer to camera. There's no cheaping out on wires here. Use a diversity system, or a high-quality non-diversity, or a wireless hop system for this application to ensure all your fantastic tracks make it to the camera.

The wireless hop has many advantages but one major disadvantage—you have no way of knowing if the sound is getting to the camera free of drop-outs. The sound is only transmitted to the camera; it's not being transmitted back for you to monitor. You have no idea if the sound is actually getting there.

Figure 8.22

The solution to set my mind at ease is twofold: First, the camera operator must always wear headphones. I make it very clear that he or she needs to pay attention to the audio or I'll have to cable in. Second, I'll record a back-up on a separate audio recorder, just in case the wireless feed was compromised in any way.

I rarely use a control cable for motion shots anymore, but I always use one for interviews.

WIRELESS HOP SETUP

Setting up a wireless hop can be a little tricky. There are several places where the calibration can go wrong. Follow closely, there's quite a few steps.

Before you calibrate the wireless receiver to the camera, you must first calibrate the camera with your field mixer:

1. Set up your mixer using the "Initial Setup Procedure for a Field Mixer" in Chapter 3. Use a control cable, snake, or XLR cable to connect to the camera. You'll be sending "Mic" level to the camera, so make sure to set the mixer's output to "Mic."

WIRELESS SYSTEMS

Figure 8.23 Wireless hop to camera

2. Calibrate the camera according to the procedure under "Professional Field Mixer Input" in Chapter 9, "Video Cameras." Make sure you calibrate the camera to receive a "Mic" level input.

 By first calibrating the camera with tone generated by your mixer, you're making sure the camera is set to receive a perfect "Mic" level that has not been attenuated in any way. The meters on the camera will be your reference level when you calibrate the wireless receiver.

3. Detach the cables from the camera.
4. Connect a wireless transmitter to the left XLR output on your mixer. Make sure you have the proper cable. Don't use adaptors.
5. Connect your back-up recorder to the right XLR output on your mixer. Again, make sure you have the proper cable.
6. Set the mixer's left output select to "Mic." This will send a "Mic" level to your wireless transmitter.
7. Set the mixer's right output select to "Mic." This will send a "Mic" level to your back-up recorder.
8. Power up mixer and wireless transmitter.
9. Speak into your mic and make sure it is working and the signal is present on both meters.
10. Calibrate the wireless transmitter using both tone generator and voice. First, engage tone on your mixer and adjust the input on the transmitter so the input meter on the transmitter is reading about three-quarters full. Disengage tone.

11. Next, speak into the microphone and (if needed) fine-tune the AF input level on the transmitter until the AF peak LED flashes occasionally (see "Calibrating the Transmitter" earlier in this chapter). Make sure you're operating your mixer at unity.
12. Attach the wireless receiver to the camera and plug it into input CH1. Make sure to use the proper cable.
13. Plug your headphones into the camera's headphone jack.
14. Power up the camera and receiver.
15. Engage tone on your mixer and adjust the receiver's output level until the camera's meters are the same as when you calibrated the camera with cables and field mixer in Step 2 (see also "Calibrating the Receiver to a Video Camera" earlier in this chapter).
16. Put on your headphones and listen first to tone. Make sure it is crystal clear, the same as it sounds when you're cabled into the camera. Next, listen to the mic. It should sound perfect as well. Look at the meters on the camera and make sure you have good level.

The mixer, camera, and wireless system are now calibrated for recording. If you want the onboard camera mic to be recording as well, set up CH2 according to the procedure under "Onboard Camera Mic" in Chapter 9, "Video Cameras."

17. Power up your back-up recorder.
18. Set the input select on your recorder to "Mic." With this setup you'll only be sending a single track of audio to your recorder.
19. Engage the tone oscillator on your mixer.
20. Calibrate your back-up recorder the same as you would a digital video camera with PPM meters. Refer to the procedure under "Professional Field Mixer Input" in Chapter 9, "Video Cameras."
21. Plug your headphones into the recorder and make sure the sound is crystal clear. Look at the meters on the recorder and make sure you have good levels.

You are ready to go! Enjoy the freedom of the wireless hop.

Once you hop it's hard to stop! That's pretty sad.

Watch Class 29—"Wireless Systems (Wireless Hop)."

CHAPTER 9

Video Cameras

Video Cameras
Common Video Camera Functions
Camera Calibration
The VJ Attenuator
Direct Microphone Input
Professional Field Mixer Input
Always Check Your First Recording!
Consumer and Professional Line Level
Label Video Tapes?

Video Cameras

In the not-too-distant past, there were two or three industry standards for professional video cameras. In fact, I would pretty much deal with one kind of camera 90 percent of the time. Today, it's a whole different story.

Every camera known to man is being used—you never know what you're going to be working with. Today's cameras are incredibly cheap and offer amazing picture quality. A significant amount of production, if not more than half, is for Web delivery, allowing camera operators to choose a camera to suit their creative style, not just for its "broadcast quality" technical specs.

They use everything from DSLRs, to small handheld cameras like the Sony EX1 or F3, to larger shoulder-mount cameras like the Panasonic P2 VariCam.

Figure 9.1

CAMERA BASICS

Wow, things have changed! Gone are the days of shooting only with professional cameras. First, camcorders showed up—that was okay, they were only used for home videos. Then prosumer cameras—what a mess they made of the industry with their mixture of professional and consumer features and functions. Now we're into DSLRs, and sadly, the manufacturers have screwed sound again.

Well the gloves are off. As the location sound operator, it's your responsibility to calibrate the plethora of cameras out there. Don't expect the camera operator to know this stuff. Most of them struggle with simple camera mic settings.

Correct calibration is an absolute must to achieve high-quality recordings. Since the camera is quite often the only recorder capturing all the fine mixing and booming you're doing, proper calibration and diligent monitoring is the only thing standing between you and an unusable mess.

To make sure you don't get caught with your pants down, find out which type of camera you'll be working with. I always ask before every shoot, *"What type of camera are we using?"* If I'm not completely sure how to set it up, I go down to my dealer of all things location audio and discuss any calibration concerns.

Figure 9.2

Figure 9.3

VIDEO CAMERAS

Common Video Camera Functions

There are certain basic audio functions that all video cameras require to record sound. Knowing what they do, and how to adjust them, makes calibrating the wide variety of cameras out there a lot simpler.

Figure 9.4

Beyond these common functions, various cameras do have many features unique to their model. You'll need to know how they affect calibration and recording. But to get you started, here are the most common functions and their settings.

FUNCTION: AUDIO INPUT LEVEL

This audio function readies the camera to receive a signal from a mixer, direct mic input, wireless system, and/or camera-mounted mic.

Figure 9.5 Input levels on the body of the camera

VIDEO CAMERAS

Figure 9.6 Input level on handle of a smaller video camera

Setting Choices: Line, Mic, Mic +48Vph, Mic Att, Camera Mic

- Set to "Line" when connecting a mixer to a video camera.
- Set to "Mic +48Vph" when directly connecting a shotgun microphone or hard-wired lavalier.
- Set to "Mic" when directly connecting a handheld dynamic microphone or wireless system to a video camera.
- Set to "Mic Att" (mic attenuation) when using the onboard camera mic in a loud or windy location. This function is found only on cameras with a built-in microphone.

FUNCTION: INPUT SELECT (1)

This audio function on the smaller handheld cameras is for selecting the built-in camera mic or an external source.

Setting Choices: Internal or Int Mic/External

- Set to "Camera Mic/Internal Mic" when you want to record using the built-in onboard camera mic.
- Set to "External" when you want the camera to record a signal plugged into the XLR inputs.

VIDEO CAMERAS

FUNTION: INPUT SELECT (2)

This audio function on the larger shoulder-mount cameras is for selecting the input that the source will be entering the camera.

Setting Choices: Front or Cam Mic, Rear or XLR inputs, or Wireless

- Set to "Camera Mic" when you want to use the onboard camera microphone.
- Set to "Rear or XLR Inputs" when you connect a shotgun, lavalier, mixer, or wireless system to the camera.
- Set to "Wireless" if the camera has a built-in wireless system.

Figure 9.7 Built in camera mic

Figure 9.8

FUNCTION: AGC

This audio function on a camera activates the Automatic Gain Control that adjusts the incoming signal up or down for optimal recording level. Also called ALC, Audio Select, Input Mode Rec. Level—manufacturers are playing "hot potato" with what this function does and what to name it!

Setting Choices: Manual/Auto, On/Off

- Set to "Auto" or "On" when plugging a microphone or wireless system directly into the camera, or using the onboard camera mic.
- Set to "Manual" or "Off" when using the camera's VJ Attenuator or connecting a mixer to the camera.

The AGC in "Auto" engages an automatic gain and limiter for the XLR and camera mic input(s). The automatic gain guarantees a good input level for the camera to record, while the limiter prevents the signal from getting too loud and causing distortion. This combination is great when there is no one monitoring and adjusting the input level on the camera. The down side is that it can create a pumping of the ambience between sentences and words. When talent speaks, the automatic gain adjusts the input level to ensure proper levels. When they stop, the automatic gain increases more to keep proper input levels (the ambience gets louder). When talent speaks again, the limiter of the AGC kicks in to prevent distortion from the new input volume, and the automatic gain adjusts down to compensate for the new louder input level. This constant up and down of volume and on and off of the limiter does not produce the most desirable recording, but it will ensure good levels with no distortion.

FUNCTION: AUDIO LEVEL

Use this function to increase or decrease the amount of signal entering the camera when in "Manual" mode. Also called Input Trim, Input Level.

- The "Audio Level" adjustment will be a pair of dials on the body of the camera in most cases, but on some of the smaller handheld cameras this adjustment will be in the camera's menu.

Figure 9.9 AGC on the body of a camera **Figure 9.10**

VIDEO CAMERAS

FUNCTION: MONITOR VOLUME

Figure 9.11 Monitor volume on the body of the camera

Figure 9.12 Monitor volume on a smaller video camera

This function on a camera is used to increase or decrease the volume going to the camera's headphone jack. The monitor volume adjustment, in most cases, will be a dial or buttons on the body of the camera.

- Set this control to "Max" when returning the signal to a field mixer via the camera's headphone jack.
- Set this function to a comfortable listening volume when the camera operator is monitoring the camera's audio with headphones.

FUNCTION: MONITOR SELECT

Figure 9.13 Monitor select on the body of the camera

184

Figure 9.14 Monitor select in a camera's menu

This camera function chooses which channel on the camera you want to monitor. Also called audio monitor, or output channel.

Setting Choices: CH1/CH2, CH1, CH2.

- Set this function to CH1/CH2 when monitoring the camera with a field mixer.
- Set this function to CH1 or CH2 if the camera operator is monitoring the camera, and you want them to focus on a single input.

Watch Class 30—"Video Camera Basics."

Camera Calibration

Calibrating today's digital cameras has become much easier due to the commonality of the functions. For example, once you've learned how to calibrate a Sony XDCAM to the various mixer and mic configurations, you'll be able to calibrate pretty much all the cameras on the market today.

Before you head out for a shoot, find out which camera you're using. If you're not sure how to set it up, do a little research. It'll be time well spent. How you calibrate the camera will depend on what you're connecting to it. To make this easy, I've broken down the various input types and given specific calibration instructions.

ONBOARD CAMERA MIC

Figure 9.15 Aftermarket shotgun mic with outdoor wind sock and goat!

The onboard camera mic has two main functions:

1. Record ambience for all b-reel shots and pick up the odd sound bite.
2. When replacing audio with sound that is recorded on a second system, it's vital the track is audible.

B-Reel and Sound Bites

The onboard camera mic can be a powerful ally for your recordings. Just because you're not actively recording the sound, a properly set up onboard mic will not only do a great job of capturing sound for b-reel, but it can also save your hide if an unexpected sound bite occurs.

Sync Track

When replacing audio with sound that is recorded on a second system, it's vital the track is audible. So for a sync track the recording needs to be high enough quality to create an accurate lock during editing.

Most camera operators know how to use the onboard camera mic, and they won't hesitate to switch over when they want to grab some b-reel. That's all fine when they're shooting by themselves, but when you, a location sound operator, are on set, it's your responsibility to guarantee there will be sound on every shot! So keep an eye on those wily camera ops, they have a tendency to sneak off and grab a few shots when you're not looking.

- I've found that built-in camera mics on many of the smaller cameras *do not* do a very good job recording dialogue. Because many are trying to create a stereo (I use the term loosely) recording, the dialogue they record does not cut well with dialogue recorded with a mono lavalier or shotgun microphone.

An aftermarket shotgun like a Sennheiser ME 64 (a great inexpensive cardioid microphone) or the new MKE600, will improve the onboard camera mic recordings tremendously!

The following setup is for an aftermarket shotgun microphone used as an onboard camera mic.

SET UP CAMERA AS FOLLOWS

1. Set the input level for CH1 to "Front or Mic+48V" phantom power.
2. Set AGC for CH1 to "Manual."
3. Set the audio in for CH1 to "External Mic" or "Rear" on professional cameras (this will select XLR Input 1).
4. Adjust the audio level for CH1 to "50 percent" volume.
5. Adjust the VJ Attenuator on the front of the camera to "10"—not all cameras have this function.
6. While gently tapping the camera mic, look at CH1 meter for signal.
7. Set the monitor select to "CH1."
8. Plug a set of headphones into the camera's stereo mini headphone jack.
9. Speak into the camera mic, and adjust the monitor volume on the camera to a level where you are hearing the signal from the mic, and not sound leaking in through the sides of the headphones' ear-cups.

By switching the input select for CH1 to "Manual," you'll have a track that won't have the pumping effect the AGC can sometimes create.

- If you're uncomfortable with the AGC being set to manual when recording onto a single channel on the camera, set it to "Auto" and breathe easier.
- If the camera has the ability to send the signal from CH1 XLR or "Front" input to both tracks on the camera, do it and adjust CH2 AGC to "Auto." This will be your onboard camera mic safety track. If all hell breaks loose during recording, you'll have peace of mind knowing that the "Auto" setting on CH2 is preventing distortion.

VIDEO CAMERAS

Watch Class 31—"Video Cameras."

The VJ Attenuator

Figure 9.16 Camera op adjusting the VJ attenuator

What the heck is that? When I started out I was told the VJ attenuator dial was an audio level control for the camera operator. Really? The last thing I want is a camera op messing with my levels! Well, after a couple of shoots I started to understand the good, the bad, and the "WTF is going on with my calibration?" to finally take notice of this little dial.

The interesting part about the little known VJ attenuator is that it's hidden, easy to bump, and can throw your whole calibration out of whack! Yet there's hardly any mention about it. So be warned and informed: cameras with VJ attenuators need to be either adjusted and taped off, or used properly and paid attention to.

Here's the skinny.

A camera operator who is comfortable with adjusting the VJ attenuation dial while shooting can make slight adjustments to an input source (CH1 only), avoiding the use of the AGC. They're only found on shoulder-mount professional cameras, but an operator who's savvy with the VJ attenuator will make you sound better.

SETTING UP THE VJ ATTENUATOR

It's not your job to train camera operators, but if an operator wants to know, here's how to set up the VJ attenuator and operate it effectively.

1. Connect your mixer to CH1 input on the camera.

2. Engage the tone oscillator on the mixer.
3. Set the VJ attenuator on the front of the camera to "7."

Figure 9.17 VJ attenuator (labeled as "mic level") set to "7"

4. If the proper calibration for the mixer/camera combination you're using is −12dB with the VJ attenuator adjusted to "10," adjust the CH1 audio level dial on the camera to bring the meters back to "−12dB."
5. If you don't have a mixer for calibrating, set the VJ attenuator to "7," have talent speak into the mic at performance level, and adjust the CH1 audio level dial on the camera for proper level. The increase shouldn't be that much.
6. Now the camera operator can make fine adjustments with the VJ Attenuator while shooting.

Calibrating the VJ attenuator at "7" gives the camera operator room to increase the volume if the incoming level is too low, or decrease it if it is getting too strong. In the viewfinder, there are input level meters. The camera operator will need to become familiar with how many of the little bars need to be lit for proper audio input level. Because there is no consistency in metering between the various makes and models of cameras, and often no numbers to indicate audio level, you may need to help out the operator. A simple input of proper audio level (look at meters on the body of the camera) compared to the metering in the viewfinder should clarify this issue.

VIDEO CAMERAS

Figure 9.18 Audio meters in the camera's viewfinder

Instruct the camera operator about making adjustments. If adjustments need to be made with the VJ attenuator, they should be done quickly. Slow increases or decreases in volume with the VJ dial will change the ambience over a longer period of time, making clean audio edits more difficult.

TIP! The VJ attenuator only affects the signal being recorded on CH1 of the camera. And don't forget to recalibrate the camera with the VJ attenuator set to "10" when reconnecting your mixer.

Watch Class 32—"Video Cameras (VJ Attenuator)."

Direct Microphone Input

If you're plugging a handheld microphone, hard-wired or wireless lavalier system, or shotgun microphone directly into the camera, follow these steps.

SET UP CAMERA AS FOLLOWS

1. Plug the microphone of your choice into XLR jack input CH1.
2. Set the input level for CH1 on the camera to "Mic" if you're using a handheld or wireless system, "Mic+48V" phantom if using a shotgun or hard-wired lavalier.

3. Set the audio in for CH1 to "External Mic" or "Rear" on professional cameras (this will select XLR Input 1).
4. Set up CH2 to record the onboard camera mic as beautifully described earlier in this chapter under "Onboard Camera Mic" (see "Set Up Camera as Follows").
5. Set the AGC of CH1 and CH2 to "Auto."
6. Set CH1 and CH2 audio level to "50 percent." Even though the AGC function will override this setting, some cameras need to have the audio level control set to anything but "0" or "Off" to activate the input.
7. Set the monitor select to "CH1."
8. Plug your headphones into the camera's stereo mini headphone jack.
9. Adjust the headphone monitor volume on the camera to a level where you are hearing the signal from your mic.

This setup is for a single shotgun, hard-wired lavalier, wireless system, or handheld microphone with the onboard camera mic recording on CH2.

TIP! All microphones benefit from the warming effect of a field mixer's pre-amps. Therefore, always use your mixer. The direct mic input method should only be used by the one-person camera operator.

You can now begin recording. The camera will power the mic, control the amount of signal being recorded, and the camera operator can monitor the recording with headphones.

If the camera has a VJ attenuator and the camera operator knows how to use it, you could set it up and better your tracks even more because you know how to do it.

Figure 9.19

VIDEO CAMERAS

Watch Class 33—"Video Cameras (Direct Input)."

Professional Field Mixer Input

To prevent damaging the camera's pre-amps, perform the camera calibration in the order outlined in the setup, which is descending order. This order will also prevent a possible screw up on cameras that have the ability to generate tone on their own. Also, *do not* put your headphones on until instructed in "Monitor Setup."

Figure 9.20

SET UP CAMERA AND MIXER AS FOLLOWS

1. Perform the "Initial Setup Procedure for a Field Mixer" on the mixer. See Chapter 3.
2. Connect the mixer to the camera: the mixer's left output into the camera's CH1 input; the mixer's right output into the camera's CH2 input; the mixer's mini monitor return cable into the camera's headphone jack if you're using a control cable or snake.
3. Set the input level on the camera to "Line." Make sure the mixer's outputs are also set to "Line."

VIDEO CAMERAS

Figure 9.21 Input level set to "Line," with a control cable connected to the camera's XLR inputs

4. Set audio in to "External Mic" or "Rear" on most professional cameras.
5. Set the AGC for both channels on the camera to "Manual."

Figure 9.22 AGC set to "Manual," audio in set to "Rear" XLR

193

VIDEO CAMERAS

6. Set the VJ attenuator on the front of the camera to "10."

Figure 9.23 VJ attenuator set to "10"

7. Engage the tone oscillator on your mixer, and turn the master fader "Off." Some mixers will send the sound from CH1 to CH4 out the master, corrupting the tone signal. Turning down the master fader will prevent this from happening.
8. Switch the camera setting to "Bars."
9. Calibrate the camera with the two assigned audio level controls. Depending on the type of meters on the mixer and camera, and if the camera is analog or digital, you need to calibrate as follows:
 - If you are using a mixer with VU meters and the camera is analog with VU meters, calibrate the camera to 0dB.
 - If you are using a mixer with PPM meters and the camera is analog with VU meters, calibrate camera to −4dB.
 - If you are using a mixer with PPM meters and the camera is digital with PPM meters, calibrate camera to −12dB.

VIDEO CAMERAS

Figure 9.24 Reference tone set at −12dB

- If you are using a mixer with VU meters and the camera is digital with PPM meters, calibrate camera to −20dB.

Figure 9.25 Reference tone set at −20dB

195

VIDEO CAMERAS

10. Switch the camera setting to "Bars."
11. Record 30 seconds of bars and reference tone.
12. Disengage the tone oscillator and return the master fader on the mixer to "0" or unity.

Figure 9.26 Alarm volume and monitor volume on camera

MONITOR SETUP

1. Set the monitor select on the camera to "CH1/CH2."
2. Set the alarm volume control on the camera to "0" or "Off" if it has one.
3. Engage the tone oscillator on your mixer, and turn the master fader to "Off."
4. Set the monitor return switch on the mixer to "Monitor/Return." You want to be listening to the signal returning from the camera.
5. Check the monitor volume on your mixer, and make sure it's not too loud. Put your headphones on. You might not hear anything—don't panic!
6. Adjust the monitor volume on the camera to match the mixer's "Mix/Direct" volume. Do this by toggling the mixer's monitor return switch between "Mix/Direct" and "Monitor/Return" and adjusting the monitor volume on the camera until the two levels are equal. If the Monitor/Return volume is lower when the monitor volume on the camera is maxed out, don't worry. It's fairly common.

Figure 9.27

CHECKING CAMERA PLAYBACK

1. After you've recorded 30 seconds of reference tone, ask the camera operator to rewind to the beginning of the tone recording and press play.
2. With the tone oscillator still engaged on your mixer, toggle the monitor return on the mixer to compare clarity and volume levels. Make sure they're the same. If there's any discrepancy in either clarity or volume, inform the camera operator first—he or she may already know of the problem. Then inform the decision maker. Doing this before the day gets going could prevent a possible disaster and potential embarrassment when playback is requested and the camera's not functioning 100 percent.
3. Stop playback and have the camera operator reset the record position. Even though I know how to perform this check, I'll always ask the camera operator for permission to perform a playback check. I've had a couple get their nose out of joint for messing with playback. After you've worked with the them a few times, they'll probably be okay with you doing it yourself.

Always Check Your First Recording!

Depending on the crew and talent, you may get heat for this delay, but you must check the first recording with talent. If you forget, you're playing with fire!

The camera may be the only recorder you have, and if it's not set up and functioning properly, the audio could be compromised. This final check will guarantee that the camera is calibrated properly, but even more importantly, that the camera is working properly. Tone can mask problems, so by checking a voice recording, you're double-checking that all is as it should be. It's rare for cameras to have only sound recording problems without picture problems, but it's better to err on the side of caution.

I've been on several shoots where the camera setup and calibration was fine, but the playback was not! On two instances in my career the camera was not working properly, and one director (even though she was really upset) thanked me for preventing a huge waste of time and money. More often than not, the monitor section of the camera is not properly calibrated (internally), and the camera operator already knows about it. Make sure you check!

Also, equipment breaks! Even though most camera operators are diligent with camera maintenance, intermittent headphone jacks, dirty playback heads, and incorrectly calibrated monitor pre-amps are common.

Most camera operators don't pay very close attention to the audio portion of their camera. "Sorry, camera dudes, but most of you don't!" You don't want to be playing

a take back for the director half way through the day, and finding out then that the playback function is not working correctly. Informing the decision maker of a playback discrepancy before the day is in full swing will prevent a very anxious and embarrassing moment.

Watch Class 34—"Video Cameras (Field Mixer Input)."

Consumer and Professional Line Level

There are two levels of "line level." Yes, you read correctly.

There is consumer line level and professional line level. I'm not going to get all spec'd on you, so just understand that consumer line level is approximately 14dB lower then professional line level. This becomes an issue when you send a professional line level from a mixer to a consumer line level camera or recorder.

Many of the early digital cameras (Sony PD150, Cannon XL1) had what appeared to be line level inputs. After distorting a few takes I realized that the professional line level my mixer was sending (+4dB) was overmodulating the consumer line level inputs on the camera (–10dB).

To make this story short and give you the solution, calibrate these earlier digital cameras with "Mic" level. I've read articles that suggest compensating for this difference—by decreasing the professional line level output to a level that the consumer line level equipment can handle. This works . . . but not very well. Even if you calibrate low enough to give enough headroom to prevent distortion, the recordings sound harsh.

Calibrate at "Mic" level, and the recordings will sound great!

Label Video Tapes?

Labeling video tapes may soon be a thing of the past. Since hard disc and cards are taking over tape formats, labeling shot media with calibration level information isn't possible—but you still need to provide calibration levels to the editor. Let the director know the level (that is, the reference tone level) you have calibrated the camera to; they can write it down and pass on the information to the editor. If you find yourself shooting tape, here's the information that needs to be on the tapes. This information is required to calibrate the input levels when digitizing in post. You must label every tape, and it's good practice to label the tape case as well.

If you calibrate the camera to –20, label it as follows: "Ref Tone @ –20dB."

Figure 9.28

CHAPTER 10

DSLR Cameras

DSLR Cameras
This Not a Cop-Out!
The DSLR Camera Mic
Onboard Camera Mic Setup
Keeping in Sync

Figure 10.1

DSLR Cameras

DSLRs have become the choice of many camera operators worldwide. The Internet is loaded with footage, good and bad, shot with these types of cameras. The pictures are great. The audio . . . not so much.

With audio being an afterthought, the ability to record quality sound with any consistency is impossible. I'm having flashbacks to the days of the Sony PD150—decent pictures but crappy audio! If you're going to shoot video with dialogue on a DSLR camera, I strongly recommend recording audio on a separate recording system and syncing up the audio in post.

DSLR CAMERAS

I really want to help out my DSLR mates and sound ops who are being asked to record this way, but I have no solution for recording dialogue *onto* the camera. Yes, I can get it there, but my ulcers would burn right through from the anxiety of knowing the recorded audio isn't perfect.

You're not getting paid to record barely passable audio.

I've been on many shoots with DSLRs, and the only audio recorded onto the camera is ambience and sync track. All dialogue is recorded onto a separate system.

This Not a Cop-Out!

Audio meters, a headphone jack, and proper XLR connectors are the bare minimums needed to calibrate, record, and monitor any sound recording. If someone gives you the "I've done it before, it'll be fine," or the "I've seen it done on YouTube" comment, suggest they shoot without looking in the viewfinder—you've seen it done on YouTube!

By taking a show that has you recording dialogue onto a DSLR, you're setting yourself up to fail. If there's no time or budget to run a second system, turn the gig down.

Figure 10.2

The DSLR Camera Mic

Let me be blunt, the built-in camera mic on a DSLR is a piece of !?#! I think it's because Canon wasn't expecting the video function of the camera to be such a big hit—so the $0.49 mic makes sense. But still, you'd think they would have at least

tried to improve it by now! Luckily, there are manufacturers who are happy to create and build some pretty great mics to help us out.

To up the quality of your ambience recordings, there are some pretty good aftermarket camera-mounted mics designed specifically for the DSLR. They'll improve the sound recorded on the camera immensely! You can buy mono and stereo mics. They come with an 1/8-inch connector. They're battery-powered to boost the signal to improve the camera's signal-to-noise ratio. They come with a mounting bracket and shock mount to help isolate the mic from camera handling noise, and Rycote has even designed windjammers so you can record outside. And now, Shure has put out a mic that records on a removable flash drive, so you don't have to worry about the crummy 1/8-inch connector going faulty. The hardware is now available for you to record quality ambience and sound bites.

Figure 10.3 Shure VP83F LensHopper

Figure 10.4A

Onboard Camera Mic Setup

There's not much to set up when using one of these aftermarket mics designed for the DSLR. I would recommend contacting the camera operator before the gig to make sure he or she has updated the camera's software so you'll have meters.

1. First, and always first, *check* the batteries in the microphone!
2. Plug the camera-mounted mic into the 1/8-inch mini input on the camera and attach the mic to the camera's hot-shoe. As soon as you plug into the 1/8-inch jack the camera automatically switches to that input source. See Figure 10.5.
3. Set the "Sound Rec." on the camera to "Manual." The AGC (Auto) on the DSLRs is terrible. See Figure 10.6.
4. Set the wind filter to "Disable." I've seen this function "grayed out" on cameras as soon as you plug a mic into the 1/8-inch mini. If the camera you're setting up does this, omit this step.
5. Turn the mic on and make sure you've got power. I recommend choosing a camera-mounted mic with an "On/Off" switch and light to indicate the mic is on. It's nice to know the mic is on when you're recording. See Figure 10.7.
6. Speak into the mic and adjust the "Rec." level on the camera so the peaks are around −10dB. You can record hotter, but you'll be exposing yourself to possible distortion. See Figure 10.8.
7. Record 30 seconds of audio and then play it back. The only way to hear if the mic is working is to play back a recording through the crappy little built-in speaker—at least you'll know something's been recorded.

Figure 10.4B

DSLR CAMERAS

Figure 10.5

Figure 10.6

Figure 10.7

Figure 10.8

Keeping in Sync

One of your main concerns when recording with DSLRs is sync. The sync track is the sound you record on the camera that will be replaced in post by the sound you record on a second system. For sync to work properly, there needs to be either a decent quality recording of the audio you are replacing on the camera and/or a sync point, a sharp quick sound at the beginning of every take recorded on the camera. Editing software will sync the wave forms recorded on the DSLR with the wave forms recorded on the second system if they match—it's pretty cool technology.

There are many ways to create sync sound and/or a sync point.

Figure 10.9

DSLR CAMERAS

For the sync point, video crews are using film slates—that's right, the slate is showing it's irritating self in video, and with the latest DSLR having time code, we can enjoy sync slate nightmares. "Sticks," as they are called, with the date, scene, take, and maybe even the director's name, are gracing the bags of video camera and sound ops. But the reality is most video is a two-person crew, each wearing more then one hat, and the slate isn't very practical. To be honest, it's a real nuisance! "Did we forget to slate again?" and "Who's got the dry erase pen?"

So how do we do it in the real world? With a clap of your hands and a verbal ID. When the camera op rolls, so do I. I ID the audio file—let's say, "wave 52,"—the camera op verbally identifies the shot if needed, and then a single hand clap and we're off. The camera-mounted shotgun picks up the clap and so does my mic, so we have our sync point.

For sync sound, the sound recorded on the DSLR during the entire take needs to be of decent enough quality so the editing software can line up the waves of the two sound files. I like to set up a wireless hop to the DSLR to guarantee a perfect sync track, but a camera-mounted mic works just as well.

In both cases, when the show is cut together, the editor blows off the sync sound recorded on the DSLR and replaces it with the much better recording of the second system. This has worked flawlessly for me for over five years—no sync issues.

The only time it gets tricky is when the talent is far away. If the talent's wearing a wire, you're going to have to make sure you record the sync clap close enough to the camera op to prevent a delayed sync point. Stand close to the camera op and use either the slate mic function on your mixer, or simply use your shotgun mic to record it.

If you're booming talent that's far away from the camera (long-lens shot), boom over to the camera op for the sync clap (no further then six feet away to prevent sync delay), then back to the talent to begin the shot.

TIP! It's good practice to start your recorder and ID every time camera rolls when recording dialogue. If camera cuts, you should stop as well—it's easier in editing when the number of sound clips and video clips are the same.

Figure 10.10

Syncing sound and picture in post is a time-consuming process in DSLR video production. But working with the camera operator to implement a simple yet effective way to identify takes and create an accurate sync point will make the editor's job a lot easier.

Watch Class 35—"DSLR Cameras."

CHAPTER 11

The Field Recorder

The Field Recorder
Thanks DSLRs!
Portable Digital Audio Recorders
Calibrating Your Mixer to a Portable Field Recorder
The Future of the Field Recorder

The Field Recorder

I'm back in film! Well that's what it feels like with carrying around a recorder again. For years I enjoyed not having to "roll sound." I liked sending sound to the camera to be recorded. No labeling reels, or DAT cases, no sync issues—life was all about getting the best quality sound into and out of my mixer.

Figure 11.1

Thanks DSLRs!

Now we're basically back where we started from before 3/4-inch tape. The only good part is the field recorders are *frickin' awesome!*

I forgot how nice it was to be able to check my recordings whenever I felt like it, and to take my recordings home and critique them on something other than a set of headphones right after a take—I really, really like it!

The recorders on the market today are amazing. They sound great, most are very easy to operate, and there's no camera crap cluttering up the needed audio functions. Best of all, there's no tape! Just little memory cards that magically upload onto your computer. I'm getting all warm and fuzzy just writing about it.

So why do we still record on the camera, you may be wondering? Well, because we can, and we've been doing it for over 20 years. Most companies are comfortable with picture being married to sound in the camera, and they're set up for it. But the times they are a changin', as Mr. Dylan put it, and so must we.

Figure 11.2 Sound Devices 664 mixer with built-in recorder

Portable Digital Audio Recorders

There's a variety of portable digital sound recorders on the market today. Like most things, you get what you pay for, but some of the lower-priced recorders sound very

THE FIELD RECORDER

good and work well for location audio. Most recorders are set up to be standalone units, and most tie in seamlessly with a field mixer. Some have built-in mics that are handy for quick ambience recordings, while others are strictly recorders.

Many of the portable recorders I see being used in video production appear to be designed more for music recording then video production, but they still work fine. With built-in effects, a metronome or tuner, even mixing capabilities, some units can be a little cluttered—so be aware of that when purchasing.

But with all this audio goodness potentially clouding your judgment, there are certain features you'll want to have when purchasing. Here are a few features I look for in a field recorder. You may have others, but for location audio these are must-haves!

Figure 11.3 Zoom H4n portable recorder with mics

- XLR inputs are a must—I'm not a fan of the 1/8-inch stereo mini as an input. I want the connection to my recorder to click or snap or lock-in in some way. XLRs are professional audio connectors, and your recorder must have them.
- Easy to reach and read "Rec/Stop/Play" buttons—Some recorders have too many buttons on the front, or not enough, and you're constantly scrolling through menus. Some have needed buttons in hard-to-reach places when the recorder is in your mixing bag, or they're so small you need a microscope to see them. Take a moment when choosing a recorder to visualize how it'll fit and work in your mixing bag.
- Big, easy-to-read display—Maybe I'm just getting old, but some of the meters are so small they're hard to read. In bright sunlight some of them disappear. Don't be sold a unit if you can't see what's going on. Take the unit outside and make sure. Clearly labeled large meters are very important.
- Strong construction—Location audio is tough on gear, so if your recorder is made of plastic it probably won't last. Make sure the recorder can handle the rigors of being in the elements. Check out reviews regarding reliability in hot and cold environments—humidity is a big killer. Do your homework!

- Removable storage—I don't like having all my files on one card, or one drive, or one of anything. I use several four-gig SD cards instead of one big one. After recording for a couple of hours, I put in a new card, and pack the recorded card safely away. As soon as the shooting day is done, I dump the files into my computer and duplicate them on a separate hard drive.

Calibrating Your Mixer to a Portable Field Recorder

Calibrating a field recorder to receive a signal from a field mixer is very simple. The steps you learned when calibrating a field mixer to a video camera are the same, except there's no camera stuff getting in the way. Here's a simple setup using a Zoom H4n:

1. Connect the mixer to the recorder: the mixer's left output into the recorder's CH1 input; the mixer's right output into the recorder's CH2 input; the mixer's mini monitor return cable into the recorder's headphone jack, if you're using a control cable or snake. See Figure 11.4.

2. Engage the tone oscillator on the mixer.

3. If the recorder has an input level adjustment, set it to "Line," and set the mixer's outputs to "Line." If you cannot find a switch or setting that reads "Input Level—Mic/Line," the recorder's XLRs will most likely be a "Mic" input, so set your mixer's outputs to "Mic." Many of the smaller portable recorders will have a choice between the built-in mics and the XLRs. See Figure 11.5.

Figure 11.4

Figure 11.5

THE FIELD RECORDER

4. Many of the smaller portable recorders may have features like low cut, compressor, AGC or auto level, phantom power, and mid side encoding—turn all these functions "Off." See Figure 11.6.

Figure 11.6

5. Choose a file format. The higher the bit rate, the quicker the card will become full. I record at 48kHz/16bit. See Figure 11.7.

6. Hit the "Rec" button to ready the recorder to receive the tone from your mixer.

7. Calibrate the recorder with the "Rec Level" buttons set to −12dB. See Figure 11.8.

Figure 11.7

Figure 11.8

THE FIELD RECORDER

8. Set the monitor return switch on the mixer to "Monitor/Return." You want to be listening to the signal returning from the recorder.
9. Adjust the "Monitor/Headphone" volume on the recorder to match the mixer's "Mix/Direct" volume. Do this by toggling the mixer's monitor return switch between "Mix/Direct" and "Monitor/Return" and adjusting the monitor volume on the recorder until the two levels are equal. See Figure 11.9.

Figure 11.9

10. Record 30 seconds of reference tone.
11. Disengage the tone oscillator.
12. Play the file back. It should sound as good as it sounded when you recorded it.
13. For one last check, I like to record a little bit of voice and play that back as well. Tone can sometimes mask hiss and hum. This is just my paranoia kicking in—I like to be 100 percent positive everything is working properly.

This setup will help the beginner understand the steps necessary to connect and calibrate a portable recorder to a field mixer. I know Sound Devices, Zaxcom, and other manufacturers have recorders designed to connect and calibrate seamlessly with their field mixers. If you're working at that level in the location audio world, you probably know the nuances and quirks of your setup.

THE FIELD RECORDER

Figure 11.10

The Future of the Field Recorder

By the time you read this there will be more advances to the field recorder. I'm pretty jacked right now, since moving into a field mixer with built-in recorder (Sound Devices 664). If you're serious about location audio, the new professional will be using this type of system. The best part—all the techniques needed to record quality audio in the field do not change, they just get a little easier to manage.

Watch Class 36—"Digital Field Recorder."

CHAPTER 12

The Interview

The Interview
Who's Decision Is It?
Here's How an Interview Works
The Long Overdue Meeting
Nonverbal Communication
Be Prepared
Conclusion

The Interview

Having a positive impact on an interview is very important to the advancement of your career. Since the hiring of a sound person for a shoot is quite often dictated by interviews, it's vital you are making the process easier rather than more difficult. I have worked with interviewers who were so impressed with my concern regarding the flow of their interviews, that they started to request me for all their shoots. By helping the interview move forward smoothly with as few disruptions as possible, you'll quickly become their first choice.

Who's Decision Is It?

Figure 12.1

Interviews can be short, like the "man on the street" interview, or the painful hour-long interview of "trying to draw out coherent statements." Nothing gets an interviewer more upset than having to stop and restart during a tough interview. A frustrated interviewer once said to me, "At least let me get through the warm-up!"

After recording hundreds of interviews, it was clear I had no idea how the interview process worked. I never knew what the interviewer was after, or how they went about drawing out information.

Figure 12.2

After years of dirty glares and having to justify my reason for needing another take, I figured out how to aid rather than hinder the process. I learned that a large part of an interview is "fluff," as the interviewer gets the talent to relax. Many interviews are focused around one or two main questions, and the more I learned the more it became clear that I, as the location sound operator, would never stop another interview.

Here's How You'll Conduct the Interview Process

The first step in the interview process is to find out the context and content of the interview, and then choose an appropriate location to meet these needs. You need to know how the interview will be used throughout the final product.

Here's an example: Let's say you're recording an interview in a computer lab. The ambience that defines the computer lab (hum from computers, fingers tapping keys, fluorescent light buzz, etc.) will be under and a part of the interview. Since the ambience cannot be separated from the voice, it's important that the content of the interview be used only over b-reel shot in and around the computer lab.

Now if we take the same interview recorded in the computer lab and place b-reel shots of the talent walking in a park or reading a book, the ambience from the interview becomes an issue. The viewer would expect birds and rustling leaves under the park shots and silence under reading shots, not fluorescent light buzz, air conditioning, and computers. You see—or should I say, you hear—the problem?

Make sure you ask the decision maker how and where the interview content is going to be used throughout the final production. If they are not totally sure how the content will be used, it'll be super important to choose a location with as little ambience as possible.

The Long Overdue Meeting

It's time for you to bring a new interview process to your next gig—and to have a very important conversation that's going to change the way interviews flow when you're the sound operator on set.

The traditional protocol for an interview is that the interviewer asks questions, the talent answers, the camera operator shoots, and the sound operator records the sound and stops the interview every time there's an extraneous sound. Well goodbye 1995, and hello 2014!

If you're like me, you're probably tired of the crap that comes with extraneous sounds that occur during interviews—like it's your fault, right? You caused the airplane to fly by, and you deserve a stern look—you should be interrogated, and you feel shame.

That's not how you're gonna do it anymore! You can hug me later. You're going to teach the interviewer how to control the entire interview, and they're going to love you for it.

To start, you're going to inform the interviewer that if the recording is being compromised in any way due to an extraneous sound, you won't be stopping or disrupting the flow of the interview. Instead, you're going to shake your head "no" to communicate that the sound is unusable. You will not be stopping the interview! If the interviewer needs what the talent said during an unusable section, he or she will need to ask for it again; but if the issue was during an unnecessary section, the interviewer can move on.

Figure 12.3

Figure 12.4A

THE INTERVIEW

With a simple head shake, you've informed the interviewer that the audio is unusable, and there's no debate—you've done your job.

Now think about this for a second. You will no longer be stopping interviews. You'll no longer get into the "Are you sure it's not usable?" discussion, or my favorite—"It didn't seem that loud to me." You're just going to shake your head "no" and leave it to them to decide whether to proceed or repeat the question. It's that simple.

Figure 12.4B

Nonverbal Communication

Most interviews in video are journalistic style, meaning the interviewer will not be seen or heard in the final product. The interviewer is just there to ask questions. This type of interview allows for nonverbal communication. Check with the producer before the interview begins.

To communicate audio issues with a simple head shake or nod, you're going to choose a booming or mixing position where the interviewer can easily see you. This position will always be opposite the key light or main light source lighting the talent, and just outside the light's main beam. If you're booming, stand facing the interviewer with your body 90 degrees to the talent. If you're using a lavalier, position yourself in the same area even if you're sitting.

Figure 12.5

Figure 12.6

THE INTERVIEW

When you do nod to the interviewer, it's done slowly. You don't want to distract the talent—no bobble-head dolls. Let the interviewer know you may not look at them for acknowledgement, and that he or she should be discreet if and when acknowledging you. The interviewer should be able to see you out of the corner of his or her eye. Before the interview starts, position yourself and show the interviewer what you will do to communicate audio concerns.

Many interviewers will not be familiar with this communication method but will quickly grasp the benefits of working this way.

Be Prepared

Just like any shot during the day, you need to be prepared for the interview. Your mixer should be set up with the mic(s) you are going to use, the camera should be calibrated, the location should be prepped, and any information regarding possible sound issues should be conveyed to the decision maker.

But from here on the interview takes on a little different process.

When the talent arrives (star or not), the interviewer is going to take over. They'll get talent talking right away with introductions and probably get them to sit down and just keep talking. The camera operator will start tweaking their lights (as always), and a good three minutes will pass. Do not waste this time chatting or moving lights and props for the camera op (even though it's a really great thing to do, just not yet), but rather "dial in" your mixer as outlined in the section "Task #2—Dialing In," in Chapter 4, "Field Mixer Operating Techniques." It only takes 20 seconds, and you'll be ready when recording begins.

Figure 12.7

Most interviews will have a definitive start—we've all heard, "Okay, whenever you're ready," or "action!" But I've been on many interviews where the interview starts without anyone calling for it—a "soft" start. This type of start to an interview tricks nonprofessional talent who are really nervous—they think we're still setting up, and before they know it the interview is in full swing, or even over. You need to be ready, so make sure you take care of business relating to sound before you become a light or set dec.

And to finish off every interview, record 30 seconds of room tone as I described in Chapter 4, "Field Mixer Operating Techniques."

Conclusion

As I ironed out this process, it became clear that all parties involved with the interview were benefiting. As I became more confident with explaining the process, it became easier to sway interviewers and decision makers to work this way.

The interviews moved swiftly with less interruptions. But the one who benefited most from this procedure was me. No more worrying about the conflict that would follow every stoppage—I was able to focus 100 percent on sound.

For the interviewers, they quickly realized that they would not be disrupted, and they had total control. If there was a sound issue, they could repeat the question without the talent even knowing there was a problem—something that is very unnerving for nonprofessional talent. The real savvy interviewer would move in and around sound concerns seamlessly. A lot of love was flowing my way—the process was a success.

Watch Class 37—"Interview Technique."

INTERVIEW QUICK LIST

- Discuss with the decision maker the context and content of the interview.
- Choose a location to meet the production's needs for the interview's content.
- Discuss nonverbal communication with the interviewer.
- Be prepared—set up the mixer and camera, and choose your mics before talent arrives.
- Choose a booming/mixing position opposite the key light.
- Use the time for introductions and light tweaking to dial in your mixer.
- While recording, use nonverbal communication.
- Use the three booming positions for static booming to prevent fatigue.
- Immediately after the interview, record 30 seconds of room tone.

CHAPTER 13

Add-Ons

Handheld Microphone
Microphone Flasher
Wireless Monitoring
Must-Have Accessories
Happy Recordings!

Handheld Microphone

The handheld mic is used primarily for the "reporter on location" type of commentary or interview. You've probably all seen "streeters," as they're called—a reporter holding the mic, moving it back and forth, asking questions to passers-by and talking to camera. Like any other application, there is a right and wrong type of mic for the job. Just because you can hold a mic in your hand doesn't make it a handheld mic! It's embarrassing when a reporter is holding an ME 66 shotgun microphone six inches away from his or her mouth. It looks and sounds like crap!

Figure 13.1

ADD-ONS

There are dynamic handheld microphones designed for this application that are very effective. Dynamic mics have a short pick-up range, making them perfect in loud locations.

Handheld mics are excellent for extremely loud locations. Even behind the stage of a rock concert you'll be able to record intelligible dialogue. You'll have to PAD down the signal, but the dialogue will be clear.

Handheld mics are available in both hard-wired and wireless versions—both work great. If you choose to go wireless, you can buy a separate system where the transmitter is built into the mic and comes with its own receiver. These mics are not as bulky as the transmitter plug-in adaptor that fits on a regular handheld. If you already own a wireless system, you may be able to buy an adaptor for that system. An even less expensive wireless option is to get a cable made up that will attach to the transmitter of the system you own.

Teach reporters how to use these handheld mics. Remind them that the audio will only be as good as their ability to position the mic correctly. On a few occasions, I've had inexperienced talent using it as a pointer—yikes! For best results, the mic needs to be pointed directly at the mouth, no further then ten inches away. The louder the location, the closer the mic needs to be.

Figure 13.2

Make a proper dynamic handheld mic part of your package; your retailer of all things location audio will have a fine selection.

ADD-ONS

Microphone Flasher

It's a good idea to ask the producers if they'll need a flasher for the handheld mic. That's the plastic cube-like thing with the logo of the broadcaster or television program on it that fits onto the stem of the mic. It's a detail that is often overlooked, and it shows you're on the ball. The client will usually supply the flasher.

Wireless Monitoring

A Comtec system is a wireless headphone system that allows the client, director, and/or producer to monitor the performance if they are not close enough to hear the dialogue clearly. The signal is transmitted from your mixer to as many receivers with headphones as you choose.

Figure 13.3

Figure 13.4

Comtec is a brand name of a wireless listening system. Like Kleenex, it's become the name that is used in the industry for these types of systems. They aren't cheap to purchase, so if you're not using the system on a regular basis, I suggest renting it from your favorite retailer of all things location audio when your client requests them. Make absolutely sure they supply the proper cable to connect to your mixer.

223

ADD-ONS

Must-Have Accessories

CARRYING CASE OR BACKPACK

Figure 13.5

There are cases and backpacks designed specifically for shipping and carrying your location audio equipment. Hard-shell cases made by Pelican are a must if you're going to be doing any flying. Softer bags and backpacks made by companies such as Kata and Porta-Brace have adjustable compartments and nets, making storage a breeze, and preventing your equipment from getting damaged during the rigors of travel.

RAIN SOCK FOR A SHOTGUN MIC

When you've worked in the rain a lot (like the west coast of Canada), you learn to adapt. To prevent your shotgun mic from getting wet when it's raining, there is a rain sock for your shotgun blimp system. Personally, I think they're ridiculously overpriced! A simple, cost-effective solution is to use quilt batting. What the heck is that, you ask! It's the spongy white porous material used to fill quilts. It comes in a big sheet. You need to go to a fabric shop to purchase it.

Figure 13.6

224

You're going to wrap the entire Rycote or Softie with it, and use elastics to hold it on—leave the capsule end open. Your mic ends up looking like a marshmallow on a stick, but it works great! The rain dissipates when it hits the batting, minimizing the impact on the Rycote blimp or Softie, so you don't hear it. The batting does get wet and heavy due to the added water, so you have to shake it out on a regular basis, but it really works well.

WALKIE-TALKIES

They're a pleasant surprise to the director or producer on location when communication over small distances (just out of shouting range) is needed. Walkie-talkies are so cheap now that for $50 you can get a pretty decent pair.

CANNED AIR

I go through cases of this stuff. Keeping your gear clean and dust-free is a must to guarantee the longevity of your equipment. Your mixer and carrying case will get dusty very quickly, and canned air cleans it beautifully. Don't allow any of your equipment to get caked with dirt; it looks very unprofessional and will eventually ruin it.

Figure 13.7

RAIN PONCHO

A cheap $4 rain poncho is perfect for keeping you and your mixer dry. Because it covers the whole body with room to carry all kinds of equipment under it, your mixer, boom pole (collapsed), and shotgun mic stay dry. It's easy to operate your mixer and pass all cables out through the arms or bottom, keeping everything dry. A hand towel is also a good addition.

METER OR BATTERY TESTER

A battery tester or meter pays for itself by preventing you from throwing out new batteries when they get mixed with old ones. You'll get maximum use out of your batteries before recycling them. If you're diligent, it will help prevent the embarrassment of your mixer dying during a shot because you had no idea the batteries were close to spent.

Figure 13.8

ADD-ONS

Figure 13.9

TOOL KIT

Multi screwdriver, butane soldering iron and solder, wire cutters/strippers, pliers, and a container to put them in. Start with these items, and add as you see fit.

Figure 13.10

PLASTIC HAIR BRUSH

It is used to brush out your windjammer or softie. For the last few windjammers I bought, Rycote supplied a very skookum collapsible brush.

If you allow the furry exterior of the windjammer to get matted, it causes all kinds of sound weirdness. The strangest distortion of sound I ever heard in the field was caused by a windjammer that was so packed with dirt it created this hollow tunnel effect. Use the brush!

Figure 13.11

Happy Recordings!

I hope my book has you well on your way to recording excellent tracks. Keep your setup simple, focus on sound, and enjoy the world of location audio—maybe one day we'll meet somewhere on this beautiful planet.

S. Dean Miles

Index

Page numbers in **bold** refer to figures.

AF input meters 165–6, **166**
ambience: amount 19–20; from below the talent 125, **125**; cancellation 123–4; evaluating 13–5, **14**; interviews 216; location 79–80; low frequencies 67, 68–9; microphones 95, **95**, **96**; quality 15–6; recording 88–9; room tone 88–9, 219; separation from dialogue 80–1
ambience beds 10, 90
ambience separation, and dialogue 19–20
appearance, professional 50–1, **51**
audio friendly locations 21, **21**
audio level, cameras 183
audio settings, cameras 9
audio signal, assigning/panning 53, **54**, 55, **55**, **56**, 57–8, **57**
Automatic Gain Control, cameras 174, 182

backpacks 224, **224**
bass roll switch **68**, 98
batteries 25, 165, **165**
battery testers 225, 226
boom poles: cable control 105, 106, **106**; choice 109–10, **110**; extension 107, **107**; grip and stance 107–9, **107**, **108**; handling noise 110–1; knuckles/collars 105, **105**; lengths 109–10, 121; prepping and wrapping 104–6, **104**, **105**, **106**
booming 103–4, **104**, **107**, 110–1, 126; on axis recording 100, **100**; cable control 105, 106, **106**; control cable 119–20, **120**; cramping 117, 118; forward and back movement 111, **111**, **112**; and lighting 124; mic angle change 114, **115**; motion 116, 118–20, **119**, **120**, 122; one-hand 120–2, **121**, **122**; pitch change 114, **115**; raising and lowering 113, **113**; scooping 125, **125**; static 116, 116–8, **116**, **117**, **118**; sweet spot 59, 123–4, **123**, **124**
B-reel shots 8, **8**, 186

cabling: control cables 46, **47**, 48–9, **48**, 119–20; Lavalier Microphones 140–1, **140**, 145, **145**, 152, 154; memory 42; pigtails 49; snake cables 46, **46**, 47–8, **48**, 49; velcro cable ties 43, **43**; wireless systems **168**; wrapping technique 38, **39**, 40, **40**, 41, **41**, 42, **42**; XLR cables 46, **46**, 47, **47**, 49
camera operators 8, 87–8, **87**, **88**, 119, 120, 189, 197
camera-mounted microphones **182**, 187; DSLR cameras 201–2, **201**, **202**, 203, **204**, **205**
cameras: audio settings 9; initial calibration 35–7, **36**; monitor select 77; tying into 46–9, **46**, **48**, **49**; voice-overs 11; wireless hop setup 175–7, **176**; wireless hops 174–5, **174**, **175**; wireless receiver calibration to 172–4, **172**, **173**; wireless receiver mounting 167–8, **167**; wireless transmitter calibration to 173
cameras, DSLR 200–7, **200**; microphone set up 203, **203**, **204**, **205**; microphones **201**, 202–3, **202**; speaker 203; sync 205–7, **205**, **207**
cameras, video 178–99, **191**, **192**; audio input level 180–1, **180**, **181**, **182**; audio level 183, **183**; audio meters **190**;

INDEX

automatic gain control 174, 182, **183**;
calibration 179, **179**, 185–7;
direct input 190–1; field mixer input 192, **193**, 194, **194**, **195**, 196, **196**;
input select (1) 181, **181**; input select (2) **182**, 182; line level 198; microphones **181**, 182, 186–7; monitor select **184**, **184–5**, **185**; monitor volume 184, **184**; playback checks 197–8; VJ attenuator 182–3, 188–9, **188**; VJ attenuator set up 189–90, **189**
cancellation ports 92
canned air 225, **225**
carrying cases 224, **224**
channel fader 25–6; adjustment 61–2, **62**
channel gain 26; setting 63, **64**, 65
channel panning 30–1, 72, 78
clothing noise 137
comfort 37–8
communication 15–7, **16**
Comtec 223, **223**
consistency 82
consumer line level 198
control cables 46, **47**, 48–9, **48**, 119–20, **120**
cramping 117, 118
critical listening 78–9

dialing in 58–9, **59**; channel fader adjustment 61, **62**; limiter settings 69–70, **70**; master gain adjustment 31, **60**, 61; metering 62–3; mic placement 59, **59**, 60; PAD settings 63–5, **63**, **64**; steps 59
dialogue: and ambience separation 19–20; ambience-free 12; consistency 101; and framing 81–2; location recording 6; microphones 92–3, **92**, **93**, 95, **95**; performance volume 20; separation from ambience 80–1; tonal quality 80–2, **81**, **82**
directors 21
distortion prevention 98–9
distractions, avoiding 83–4
diversity systems 161, **162**, 175
DPA4017B 94
dress 116, **116**

ears, training 84
editors 13
exposed lavalier technique 137–42, **138**, **139**, **140**, **141**, **142**
extraneous sounds 13–5, 18–9, 82, **83**, 86–7, 217–8

Field Mixer Initial Setup procedure 33, **33**; four-channel 33–5
field mixers 22–51, 37; camera connections 46–9, **46**, **47**, **48**, **49**; camera input setup 192, **193**, 194–5, **194**, **195**, 196, **196**; carrying 37–8, **37**, 43, **43**, 45; choosing 23; field recorder calibration 211–3, **211**, **212**, **214**; four-channel 33–5; headphone attachment 44, **45**; pan dials **54**, **55**; pre-amps 191; rig 37; shotgun microphone connections 49, **49**; wireless receiver calibration 168, **168**; wireless receivers 49–50, **50**, 56, **56**, 57
field mixers, features 23, **23**; batteries 25; channel fader 25–6; channel gain 26; channel panning 30–1; external power 25, **25**; high-pass filter 28–9, **28**; input section **24**; input select—mic/line channel switch 31–2; internal power supply 24, **24**; limiter 30; master gain 26; meters 26; microphone power 31; monitor return 32; monitor/headphone volume 32; output section **24**; output stage 29, **29**, **30**; power supply 24–5, **24**; power switch 24; pre-amp attenuator (PAD) 26–7, **27**; slate mic 32; tone oscillator 32; XLR channel Inputs 31
field mixers, operating and monitoring techniques 52, 54; assigning/panning 53, **54**, 55, **55**, **56**, 57–8, **57**; dialing in 58–71, **58**, **59**, **60**, **61**, **62**, **63**, **64**, 65, **66**, **68**, **69**, **70**; monitor section 70–5, **70**, **71**, **73**, **74**, **75**, 76–8, **76**, **77**; during shooting 85–9, **86**, **87**, **88**
field recorders 208–14, **208**, **209**, **210**; calibration 211–3, **211**, **212**, **214**; choosing 209–11
focus 52, 54

INDEX

four-channel field mixers 33–5
framing 81–2, **81, 82**

hair brushes 226, **226**
handheld microphones 221–2, **221, 222**
handling noise, reducing 98
hard-wired lavaliers 128, **128**
harnesses 37–8, **37**
headphone select 32, 72
headphones 44–5, **45**, 88–9; design 73–4; quality **84**; settings 78; volume 73–4, **73**
high-pass filter 28–9
high-pass filters **28, 29**; bass roll-off switch 68, **69**; setting 65–9, **69**; stepped high-pass **65**, 65–7; sweepable high-pass filters **66**, 67–8, **67**; warning 68–9
hyper-cardioid microphones 92–3, **92, 93**

interviews 10–1, **11**, 83, **83**, 86, 116, 215–20, **215, 216**; ambience 15, 216; extraneous sounds 217–8; nonverbal communication 218–9, **218**; retakes 216, 218; room tone 219; start 219; technique 215–20, **217, 218, 219**

karabiners 45, **45**

labeling, video tapes 198, **199**
Lavalier Microphones 127–58, **127**; advantages 127–8, 129–30; application 135–7, **136**; application, exposed 137–42, **138, 139, 140, 141, 142**; application, hidden 143–59, **144, 145, 146, 147, 148, 149, 150, 151, 152, 153, 154, 155, 156, 157, 158, 159**; cabling 140–1, **140**, 145, **145**, 154, 159, **159**, 151151; clothing noise 137; connection 142–3; design types 134–5, **135, 136**; in glasses 156–9, **157, 158, 159**; hardwired 128, **128**; in hats 154–6, **154, 155, 156**; on the head 153–9, **154, 155, 156, 157, 158, 159**; leather clip 150–3, **150, 151, 152, 153**; moleskin attachment 147–9, **147, 148, 149**; and personal space **131**, 132–4, **132, 133**; placement 136–7, **136**, 137, 150, 154–5; power supply **128**; reach 130; skin attachment 150–3, **150**,

151, 152, 153; tie clip 137–42, **138, 139, 140, 141, 142**; vampire clip 144–7, **144, 145, 146**; in windy conditions 130, **130**; wireless 128, **129**, 142–3, **142, 143**; and women 131, **132, 133**, 150, **151**, 152, **152, 153**
lighting, and booming 124
limiter settings 69–70, **70**
limiters 30
line levels 29, 198
listening: critical 78–9; effectively 79; and headphones 84, **84**; during recording 82, **83**; during rehearsal 80–2, **81, 82**; during setup 79–80, **81, 82**; training your ears 84
lobeing 100–1, **101**
location 6; ambience 79–80; ambience evaluation 13–5, **14**; ambience quality 15–6; audio friendly 21, **21**; changing 21, **21**; choice 6–17, **6**; communication 15–7, **16**; loud 222; preparing 17–21; problems 13–5, **14**; shots 8–12, **8, 9, 10, 12**; sound match 12–3, **13**
location audio, definition 3
location audio operators: responsibilities **3**, 4; role 4
Location Audio Simplified On-Demand course 5
loud locations 222
low frequencies: ambience 67, 68–9; cutting 65; richness 101

master gain 26; adjustment **60**, 61, **61**
men, high-pass filter settings 66
metering ranges 70
mic level 29
microphone flashers 223, **223**
microphones: ambience 95–6, **95**; camera-mounted. see cameras; dialogue indoors 92–3, **92, 93**; dialogue outside **94**, 95, **95**; distortion prevention 98–9; handheld 221–2, **221, 222**; mono recording 58; placement 59, **59, 60**; power supply 31; warming 191; windsocks **130**, 137, 139, **139, 186**; . see also Lavalier Microphones; shotgun microphones

229

INDEX

Miles, Dean 3, **3**
mixer bags 43, **43**
moleskin 147–9, **147**, **148**, **149**
monitor return 32, 74, **74**; calibrating 75, **75**, **76**, 77; during shooting 87
monitor section **71**
monitor select function 72
monitor volume 73–4, **73**; cameras 184, **184**
monitor/headphone volume 32
monitoring function 71–2, **71**; channel panning 72, 78; headphone select 72; listening 78–84, **79**, 80, **81**, **82**, **83**, **84**; monitor return function 74, **74**; monitor return function calibration 75, **75**, **76**, 77; monitor select 72; monitor volume 73–4, **73**; operation 77–8, **77**; PFL function 72; in stereo 78
mono recording 58
motion booming 116, 118–20, **119**, **120**
motion shots 122
mud 109
multi-pin video connectors 46, 48

Neumann KM 150 93, **93**
Neumann KMR82 95
noise-makers 18–9
nonverbal communication 218–9, **218**

on axis recording 100, **100**
one-hand booming 120–2, **121**, **122**
online course 5
operating focus 85

pan dials **54**
pan function setup 53–4, **54**, 55–8, 56, 57
panning errors 57
performance volume 20
personal space, entering **131**, 132–4, **132**, **133**
PFL (Pre/Post-Fade Listen) 72
pick-up pattern: axis 99, **99**, 122; lobe 99, **99**; range 97; shotgun microphones 92, **92**, 94, **94**, 95, 96, 97, 99, **99**; width 96
pigtails 49
post audio editors 4
PPM (peak program meters) 26, 62

pre-amp attenuator (PAD) 26–7, **27**; setting 63–5, **64**, **65**
professional line level 198

quality audio, commitment to 1–2, 20–1

rain ponchos 225
rain socks 224–5, **224**
recording, listening during 82, **83**
recording level, limiting 69–70, **70**
reference tone 196, 197
refrigerator noise 14, 18
rehearsals, listening during 80–2, **81**, **82**
responsibilities **3**, 4
retakes, calling for 83
room tone 88–9, 219

safety tracks 35–7
scene shots 10
scooping 125, **125**
second opinions 86–8, **87**, **88**
Sennheiser ME 64 93, **93**
Sennheiser MKH50 94
Sennheiser MKH70 95
sequence shots 10
shooting 85; extraneous sounds 86–7; mic adjustments **85**; monitor return checks 87; room tone 88–9; second opinions 86–8, **87**, **88**; volume changes 86
shotgun microphones 31, 57, 90–1, **91**, 95–6, **95**, **96**; –10dB PAD 98–9, **98**; aftermarket **186**, 187; arsenal 102; axis 99, **99**; on axis recording 100, **100**; cancellation ports 101, 123; connection 49, **49**; hyper-cardioid group 92–3, **92**, **93**; lobe 99, **99**; lobeing 100–1, **101**; low-cut filter 98, **98**; medium group 95, **95**, 96; mono recording 58; pick-up pattern 92, **92**, 94, **94**, 95, **95**, 99, **99**, 122; pick-up pattern range 97; pick-up pattern width 96; power supply 97–8; rain socks 224–5, **224**; short group 94, **94**; sound perspective 96–7
shots: B-reel 8–9, **8**; interview 10–1, **10**; motion 118–20, **119**, **120**, 122; purpose 8; scene 10; sequence 10; sound match 12, **13**; stand-ups 9, **9**; static

230

INDEX

116–8, **116**, **117**, **118**; voice-over 11, **11**, **12**
shoulder straps 37–8, **37**
Shure VP89L 95
Shure VP89S 94, **94**
signal-to-noise ratio 70
skills 4
slate mic 32
slates 206
snake cables 46, **46**, 47–8, **48**, 49
sound bites 186
sound match, shots 12–3, **13**
sound perspective 96–7
sound sources 32
stand-up shots 9, **9**
static booming 116–7, 116–8, **116**, **117**, **118**
stepped high-pass filters 28, **28**, 65–7
sweepable high-pass filters 28, **29**, **66**, 67–8
sync track 186–7, 205–7, **205**, **207**
system check, four-channel field mixers 33–5

tangles, preventing 44
tonal quality, dialogue 80–2, **81**, **82**
tone oscillators 32, 61
tool kit 226, **226**

Unity 60

vampire clip lavaliers 144–7, **144**, **145**, **146**
velcro cable ties 106
video producers, commitment to audio 20–1
video tapes, labeling 198, **199**
VJ attenuators 182–3, 188–90, **188**; set up 189–90, **189**

voice sibilance 171
voice-overs 11, **11**, **12**
volume changes, shooting 86
VU meters 26, 63

walkie-talkies 225, **225**
wind 130
windsocks 130, **130**, 137, 139, **139**, **186**
wireless hops 174–5, **174**, **175**; setup 175–7, **176**
wireless lavaliers 128, **129**, 142–3, **142**, **143**
wireless monitoring 223, **223**
wireless receivers 49–50, **50**, 56, 57, **57**
wireless systems 160–77, **160**, **162**, **164**; advantages 162; antennas 164; batteries 165, **165**; cabling **168**; disadvantages 161; diversity systems 161, **162**, 175; line of sight 165; monitoring 223, **223**; range 164, **164**; receiver calibration 162–3, 168, **168**; receiver calibration to a camera 172–4, **172**, **173**; receiver output adjustment 170, 171–2, **171**; receiver setup 169–72, **169**, **170**, **171**; receivers **165**, 167–8, **167**; RF signal 163–5, **164**; transmitter calibration 162–3, 165–7, **166**; transmitter calibration to a camera 173; transmitter setup 169, **169**; wireless hop setup 175–7, **176**; wireless hops 174–5, **174**, **175**
wireless transmitters **142**, 143, **143**
women: high-pass filter settings 66; and Lavalier Microphones 131, **132**, **133**, 150, 151–2, **151**, **152**, **153**

XLR cables 46, **46**, 47, **47**, 49
XLR channel Inputs 31